ALL NEW

American

LOGO

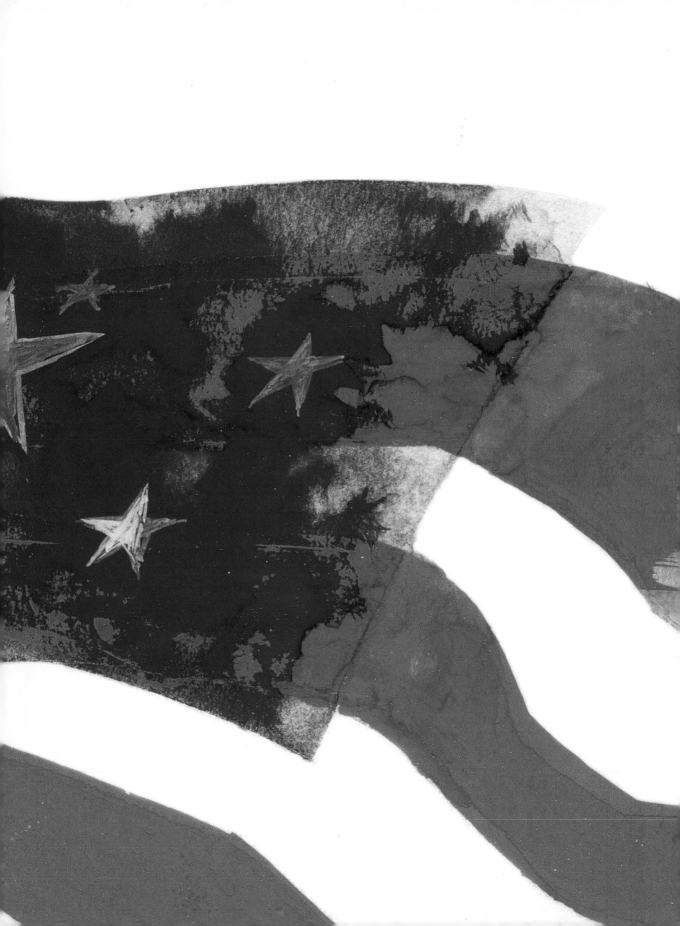

ALL NEW

American

Logo

Madison Square Press

FATHOMS

design firm David Carter Graphic Design
designer Tien Pham
art director Lori Wilson
client Atlantis Resort and Casino
logo for Fathoms/Nassau, The Bahamas.

MANUFACTURING COUNTS
CHICAGO | 1999 YEAR OF THE SMALL MANUFACTURER

design firm ComCorp, Inc.
designer Ron Alikpala
art director Abby Mines
client Chicago Manufacturing Center
logo for 1999 Year of the Small Manufacturer
 Conference (web, print, video).

CB ISBN 0-942604-77-6, PB ISBN 0-942604-78-4
Library of Congress Catalog Card Number 00 130503
Cover art by Frank Lacano

Book and cover designed by Dutton & Sherman

Published by:
Madison Square Press
10 East 23rd Street
New York, NY 10010

Fax (212) 979-2207
e-mail MadisonSqPress@AOL.com

Distributed in North American to the trade and art markets by North Light Books, an imprint of F/W Publications, Inc.
1507 Dana Avenue, Cincinnati, Ohio 45207
*1-800/289-0963

Distributed throughout the rest of the world by:
Hearst Books International, an imprint of HarperCollins
10 East 53rd Street, New York, NY 10019

Printed in Hong Kong

Acknowledgments:
This book wouldn't have been possible without the help and dedication of Arpi Ermoyan or the creative talents of Dutton & Sherman. A big thanks to all the graphic designers who made these great logos available for publication.

Contents

design firm	Kevin Akers Designs
designer	Kevin Akers
client	Motorcycle Industry Council
logo for	Promotion of motorcycle sports.

DISCOVER TODAY'S MOTORCYCLING

Introduction

In early times when few people could read or write, merchants hung pictures over the doors of their establishments to convey their ideas and depict what they sold. In America, a country of immigrants, many were literate but only in a language other than English. As more and more goods and services became available, it became increasingly important to distinguish one tradesman from another. It was but a short step to using symbols to identify which tradesmen made which product or offered which service. The symbols were easily identified and sometimes carried a message for those who could read.

These then were the first brandmarks and the first logos. Today many of those items are much sought after as antiques or wall decorations. While those symbols were a necessity for thousands of years, today we have more sophisticated ways of passing on this kind of information.

design firm The Wecker Group
designer Robert Wecker
illustrator Mark Savee
client Running Iron Restaurant
logo for Signage, T-shirts.

design firm The Flowers Group
designer Cory Shehan
illustrator Tracy Sabin
client The Ridge
logo for Rustic golf resort.

The earliest marks were very straightforward, but as more competition developed the mark expanded to include humor, puns, satire and even a bit of whimsy. Fred Cooper's symbol for New York Edison Company was dropped after many decades of use in the name of progress, but Mr. Peanut is still with us and still looking through his monocle. Both were used to identify a product and both used a light touch.

Isaac Newton said "For every action there is reaction." It is also true that each period of art is a reaction to the period that preceded it. Graphic design is no exception. The styles favored in the late 1800s and early 1900s were more personal statements. The fine work done in France and England during the Edwardian era, along with the Viennese Secessionist movements, were all hands-on movements. With the Word War I Armistice came Art Deco, a style that captures the imagination with a cross between the mechanical shapes of the draftsman and the artist's irrepressible spirits.

design firm Mortensen Design
designer PJ Nidecker
art director Gordon Mortensen
client Handspring, Inc.
logo for High-tech company.

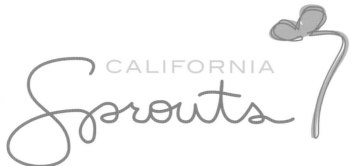

CALIFORNIA

Sprouts

design firm MJR Associates
designer Aimee McKirdy
art director Frank Ruiz
client California Sprouts
logo for Corporate identity used on stationery,
 signage and marketing materials.

As the great depression was ending, some remarkable marks begin to appear. They were strong, clever, highly imaginative and subjective. They have stood the test of time very well and one would be hard pressed today to tell a mark created in 1936 from one right out of today's computer. Since that time the trademark has grown increasingly refined and distilled.

As the larger companies expanded into new and more diversified markets the graphics they chose became less related to the companies' beginnings and were in some cases abstract. The most used logos of the time were difficult to identify—they were abstractions that reveal nothing about the identity of the company they represented. As we have passed into the new millennium this fact is still true and in some cases the largest companies have expanded and diversified to the extent that no one any longer remembers what their original product was. One has only to ponder the Time/Warner merger with AOL, forming one company that in some sense does everything.

design firm The Huge Idea
designer Lesli Wuco-B
client For Pets' Sake.com
logo for Company/Website.

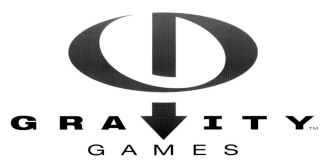

design firm Vigon/Ellis
designers Marc Yeh, Brian Jackson
art director Larry Vigon
client Gravity Games
logo for Corporate identity.

Within the last decade of the 20th century things began to change. Humor and whimsy and the craft of graphic design began to slip back into the pictures. The "ALL NEW" logo is now, the marks are more quirky; what's new is beginning to look a lot like what's old. The charm and personality of the past has a decidedly "ALL NEW" look and flavor. "ALL NEW AMERICAN" is more eclectic, more colorful and more subjective.

As the new millennium starts it has been said that the new logo is not necessarily a new phenomenon. There have always been those marks, usually created for small, creative companies that relied upon personality, wit and charm. Often the marks were created for designers and agencies for self promotion. But today, led by the music and entertainment industries, and followed closely by the clothing and computer industries, the "ALL NEW AMERICAN" logo is appearing more often. These observations and ideas are now more mainstream; many logos are again making a statement about whom or what they represent, and the change can be seen as some of the world's largest companies convert their marks to show them as they are today.

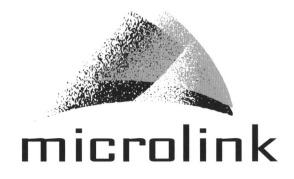

design firm Miriello Grafico, Inc.
designer Chris Keeney
client Microlink

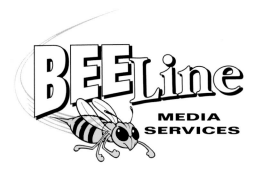

10.1

BRAEMAR
COUNTRY CLUB

10.2

10.3

10.1
design firm The Wecker Group
designer Robert Wecker
client Bee Line Media Services
logo for All applications.

10.2
design firm Vigon/Ellis
designer Marc Yeh
art director Larry Vigon
client Braemar Country Club
logo for Corporate identity.

10.3
design firm Fitch
designer Cris Logan
art director Vassoula Vasiliou
client Kärna LLC
logo for Product brand identity, packaging,
 merchandising, web for new gamer mouse.

11.1
design firm Vigon/Ellis
designer Brian Jackson
art director Larry Vigon
client Glen Annie Golf Club
logo for Corporate identity.

11.2
design firm Vigon/Ellis
designer Brian Jackson
art director Larry Vigon
client Virtualis
logo for Corporate identity.

11.3
design firm Blanco Design
designer Shelly Blanco
client Return to Freedom

11.4
design firm Leeson Design
designer Susan Leeson
client Animalia Publishing Company
logo for Animal-focused publishing company.

11.5
design firm Sandy Gin Design
designer Sandy Gin
client WOMBATS
logo for Women's Mountain Bike & Tea Society.

Glen Annie Golf Club

11.1

VIRTUALIS

11.2

Return to Freedom

11.3

Animalia
PUBLISHING COMPANY

11.4

11.4

12.1

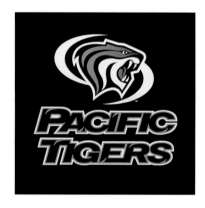

12.2

12.3

12.1
design firm Zamboo
art director Dave Zambotti
client Doggone Gourmet
logo for Corporate identity.

12.2
design firm Michael Osborne Design
designer Andy Cambouris
art director Michael Osborne
client University of the Pacific
logo for Department of athletics.

12.3
design firm Morreal Graphic Design
designer Mary Lou Morreal
client Upper Deck
logo for Trading card.

13.1
design firm Phillips Ramsey
art director Kevin Stout
illustrator Tracy Sabin
client San Diego Zoo
logo for Promotional car sticker for the zoo.

13.2
design firm John Champ Design Associates
designer Randall Cohen
client KCBS/KLLC Radio Alice@97.3
logo for Event identity for 5-mile run/walk
 and concert.

13.3
design firm Blanco Design
designer Shelly Blanco
client Lucky Dog Records

13.4
design firm Klass Design
designer Logo Doctor
art director Teri Klass
illustrators Tim Clark, Teri Klass
client Intelynx
logo for Identity for an international
 investment company.

13.1

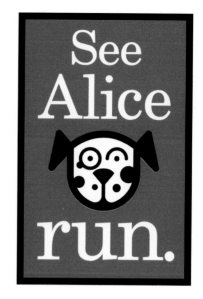

13.2

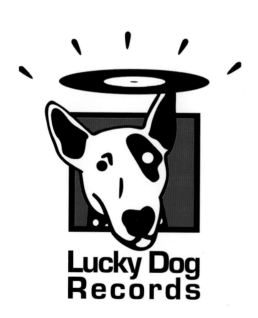

13.3

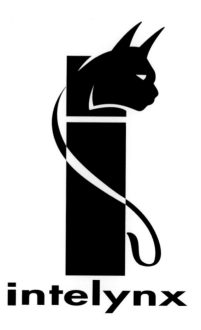

13.4

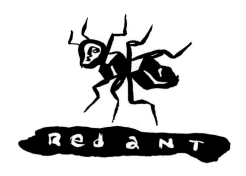

14.1

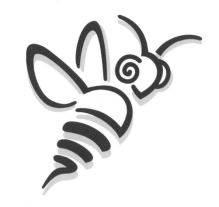

14.2

14.3

14.4

14.5

15.1

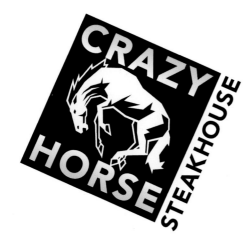

15.2

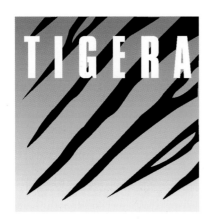

15.3

14.1

design firm Mike Salisbury Communications
designer Logo doctor
art director Mike Salisbury
illustrator Tim Clark
client Red Ant Production
logo for Identity proposal for production company.

14.2

design firm Carol Gravelle Graphic Design
designers Carol Gravelle, Shannon Karen
client ABBY Radio Station
logo for Station identity.

14.3

design firm Lawless Graphic Design
designer John P. Lawless
client Planet Magic Productions
logo for Retail line of magic and games for The
 Magic Vault.

14.4

design firm AKA Studios
designer Logo Doctor
art director Dave Brzyowski
illustrator Teri Klass
client Legacy
logo for Identity and packaging for fine linen company.

14.5

design firm The Stricklin Companies
designer Julie Ann Stricklin
art director Steve Emtman
client Steven Charles Emtman/Defender Films
logo for New company identity for title art,
 marketing, film identity.

15.1

design firm Bryan Friel Studio
designer Bryan Friel
client Rahn's Pecans
logo for Packaging, ads, website.

15.2

design firm BobCo Design Inc.
designer Robert S. Nenninger
client The Crazy Horse SteakHouse
logo for Identity for a restaurant and concert venue.
 A country music legend that is moving to
 more upscale facilities.

15.3

design firm Earlywine Design
designer Terry Earlywine
client Tigera Corporation
logo for Corporate identity, packaging, stationery.

16.1

design firm	De Muth Design
designer	Roger De Muth
art director	Ned Eisenberg
illustrator	Roger De Muth
client	Mama Gorilla
logo for	Restaurant signage, ads, T-shirts, etc.

16.2

design firm	De Muth Design
designer	Roger De Muth
client	De Muth Design
logo for	All printed materials used by artist.

16.3

design firm	De Muth Design
designer	Roger De Muth
art director	Connie Potter
illustrator	Roger De Muth
client	Once Again Nut Butter
logo for	Peanut butter/nutbutter company identity.

17.1

design firm	Alexander Atkins Design, Inc.
designer	Alexander Atkins
client	University of California, Berkeley
logo for	Alumni event.

17.2

design firm	Dutch Design
designer	Rick Smits
client	Ambrosi and Associates
logo for	Proposed logo for fund-raising marathon T-shirt art.

17.3

design firm	Sandy Gin Design
designer	Sandy Gin
client	Sandy Gin Design
logo for	Promotional logo for design studio.

17.4

design firm	De Muth Design
designer	Roger De Muth
art directors	Felicia Recht, Naomi De Muth
illustrator	Roger De Muth
client	Chameleon Gallery
logo for	Gallery signage, ads, posters, etc.

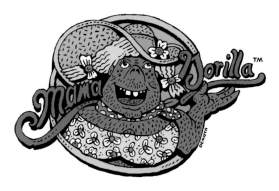

16.1

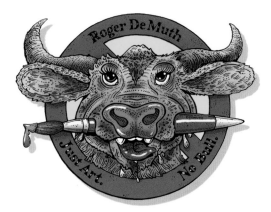

16.2

16.3

17.1

17.2

17.3

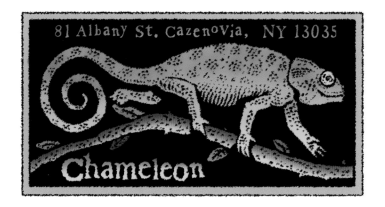

81 Albany St. Cazenovia, NY 13035

Chameleon

17.4

18.1
design firm Michael Osborne Design
designer Michelle Regenbogen
art director Michael Osborne
illustrator Michelle Regenbogen
client Margrit Biever Mondavi
logo for Theatre at Opera House.

18.2
design firm Kevin Akers Designs
designer Kevin Akers
client Tindell House
logo for English bed and breakfast.

18.3
design firm Carol Gravelle Graphic Design
designer Carol Gravelle
client Creative Concrete & Design
logo for Company identity.

19.1
design firm Sabingrafik, Inc.
designer Tracy Sabin
art director Marilee Bankert
illustrator Tracy Sabin
client Oliver McMillin
logo for Shopping/entertainment center.

19.2
design firm Kevin Akers Designs
designer Kevin Akers
client Hilton Hotels
logo for Advertising icon.

19.3
design firm Carlson Marketing
designer Logo Doctor
art director Norm Tribe
illustrator Tim Clark
client Mazda
logo for Promotional brochure and incentive program.

19.4
design firm Blanco Design
designer Shelly Blanco
client Times Square Deli

19.5
design firm Bryan Friel Studio
designer Bryan Friel
client It's a Grind
logo for Signage, ads, packaging.

19.6
design firm Bruce Yelaska Design
designer Bruce Yelaska
client Saarman Construction Company
logo for 1998 promotional logo for company's
 advertising campaign.

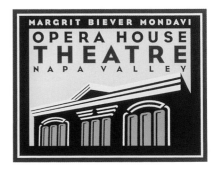

18.1

18.2

18.3

Gaslamp
SIXTH AVENUE

19.1

One Hilton
One Place to Stay

19.2

MAZDA TOWN

19.3

Times Square Deli

19.4

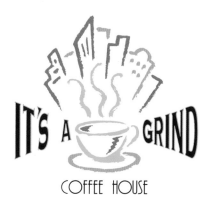

IT'S A GRIND
COFFEE HOUSE

19.5

19.6

DUBLIN HOUSE

20.1

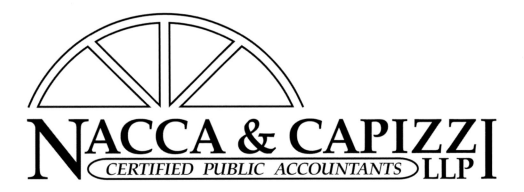

NACCA & CAPIZZI LLP
CERTIFIED PUBLIC ACCOUNTANTS

20.2

SALTZ MONGELUZZI

BARRETT & BENDESKY PC

TRIAL LAWYERS

20.3

20

THE
CAMPANILE
FOUNDATION

Supporting San Diego State University

21.1

21.2

21.3

20.1
design firm Allen Orr
designer Allen Orr
client Dublin House Irish Pub

20.2
design firm McElveney & Palozzi Design Group, Inc.
art director William McElveney
client Nacca & Capizzi LLP
logo for Letterhead, business cards, envelopes.

20.3
design firm LF Banks + Associates
designer John German
art director Lori F. Banks
client Saltz, Mongeluzzi, Barrett & Bendesky, PC
logo for Corporate identity for law firm.

21.1
design firm Juddesign
designers Eric Watanabe, Rosemary Rae
art director Patti Judd
client The Campanile Foundation
logo for San Diego State University charity
 organization.

21.2
design firm The Wecker Group
designer Robert Wecker
client San Juan Bautista Chamber of Commerce
logo for Stationery, forms.

21.3
design firm Kevin Akers Designs
designer Kevin Akers
client Hilton Hotels
logo for CrestHill, a new Hilton hotel property.

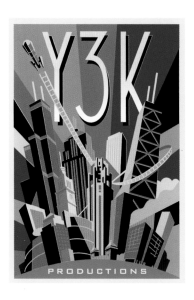

22.1

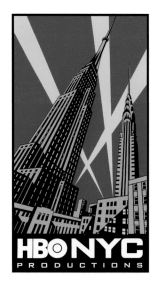

22.2

22.3

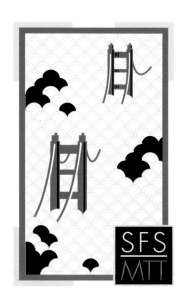

22.4

22.1
design firm	RVH Studio
designer	Paul Rogers
art director	Jill Von Hartmann
illustrator	Paul Rogers
client	Y3K Productions
logo for	Chicago-based film production company.

22.2
design firm	Heart Times Coffee Cup Equals Lighting
designer	Paul Rogers
art director	Bobby Woods
illustrator	Paul Rogers
client	HBO
logo for	New York City production company.

22.3
design firm	Dizinno & Partners
art director	Mike Stivers
illustrator	Tracy Sabin
client	Convis
logo for	Promotion for the San Diego Convention and Visitors Bureau.

22.4
design firm	Kevin Akers Designs
designer	Kevin Akers
client	San Francisco Symphony
logo for	Asian tour of San Francisco Symphony.

23.1
design firm	John Pound Art
designer	John Pound
client	Humboldt Arts Council
logo for	Promotion and grand re-opening of renovated Carnegie building as an arts museum in Humboldt County, California.

23.2
design firm	BobCo Design Inc.
designer	Robert S. Nenninger
client	The Golden Gate Bread Co.
logo for	Product packaging identity for a sourdough bread company that exports to the Japanese market.

23.3
design firm	Enigma Design Studio
designer	Logo Doctor
art director	Randy Hipky
illustrator	Tim Clark
client	Thames
logo for	Identity for British television station.

23.1

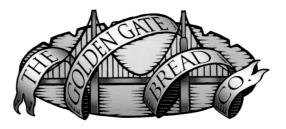

23.2

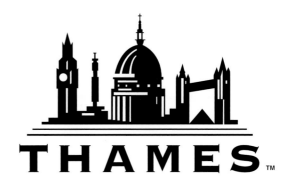

23.3

24.1

24.2

24.3

24.1
design firm The Wecker Group
designer Robert Wecker
client Robert Rosenthal, Attorney
logo for Stationery, forms.

24.2
design firm Shields Design
designer Charles Shields
client Maxim Mortgage Corporation
logo for Mortgage company.

24.3
design firm Moonlight Design
designer David Ryer
client Paradigm
logo for Investment, financial services company.

25.1
design firm Shields Design
designer Thomas Kimmelman
art director Charles Shields
client Paul D. Lerandeau
logo for Lawyer.

25.2
design firm Calori & Vanden-Eynden
designer Chris Calori
client Michael Graves & Associates
logo for Building designed by Michael Graves & Associates.

25.3
design firm Moonlight Design
designer David Ryer
client Capital Partners
logo for Financial services, venture capital firm.

25.4
design firm Vinje Design, Inc.
designer Andreas Keller
client Legacy Partners
logo for Symbol for a large commercial and residential real estate company with three major divisions.

Paul E. Lerandeau
ATTORNEY AT LAW

25.1

ONE
PORT CENTER

25.2

Capital
Partners

25.3

LEGACY
PARTNERS

25.4

26.1
design firm Vigon/Ellis
designer Daniel Cho
art director Larry Vigon
client Area 51 Advertising
logo for Corporate identity.

26.2
design firm Kahnartist Design
designer Linda Kahn
client Ray Clayton Realty
logo for Identity and stationery system.

26.3
design firm Taber Integrative Design
designer Michele Taber
client AP Thomas Construction, Inc.
logo for A fast-track, high-tech, multimillion dollar
 construction company.

27.1
design firm Dutch Design
designer Rick Smits
client Drenth Builders
logo for Stationery, business cards and signage.

27.2
design firm Allen Orr
designer Allen Orr
client The Apartment Phone
logo for Apartment search.

27.3
design firm Eve Vrla Design
designer Eve Vrla
client Lewis Development Services
logo for The Pinnacle in Kierland development
 project stationery, brochure, signage.

27.4
design firm Earlywine Design
designer Terry Earlywine
client Metropolis
logo for Sales automation software company,
 stationery, signage.

26.1

26.2

26.3

DRENTH
BUILDERS

27.1

27.2

THE
PINNACLE
IN KIERLAND

27.3

METROPOLIS

27.4

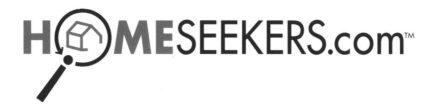

iNEIGHBORS.com

28.1

HOMESEEKERS.com™

28.2

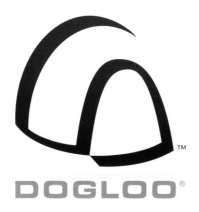

DOGLOO®

28.3

28.4

theLightHouse

29.1

29.2

29.3

28.1
design firm Tom Fowler, Inc.
designer Karl S. Maruyama
art director Thomas G. Fowler
illustrator Karl S. Maruyama
client Reynolds and Rose
logo for A website that dynamically builds a virtual
 town based on your zip code.

28.2
design firm Juddesign
designers Heidi Sullivan, Eric Watanabe
art director Patti Judd
client Home Seekers.com
logo for Online real estate resource.

28.3
design firm Zamboo
art director Cave Zambotti
client Dogloo
logo for Corporate identity.

28.4
design firm GDS Studio
designer Gary Solomon
client Rent Line
logo for Outdoor advertising on bus benches,
 bus shelters.

29.1
design firm Engle + Murphy
designer Robin Seaman
client The Light House
logo for Corporate identity for non-profit
 organization that provides transitional
 housing and services for homeless women.

29.2
design firm Bruce Yelaska Design
designer Bruce Yelaska
client Saarman Construction Company
logo for 1999 promotional logo for company's
 advertising campaign.

29.3
design firm Conover
designer Amy Williams
art director David Conover
client Addison Homes
logo for Custom home builder.

30.1
design firm Bruce Yelaska Design
designer Bruce Yelaska
client Millennium Restaurant Consultants
logo for Restaurant consulting group operating vari-
 ous restaurants in California and outside the
 United States.

30.2
design firm Calori & Vanden-Eynden
designer Chris Calori
client Arc Properties, Inc.
logo for Real estate investment company.

30.3
design firm Bruce Yelaska Design
designer Bruce Yelaska
client The Gauntlett Group
logo for Environmental engineering firm. The 2 Gs
 represent the earth and the company's
 global greening solutions.

31.1
design firm McElveney & Palozzi Design Group, Inc.
art directors Steve Palozzi, Jon Westfal
client Auto-Soft
logo for Sell sheets, software packaging for MCS Two
 Thousand.

31.2
design firm The Wecker Group
designer Matt Gnibus
client Gnibus Public Relations
logo for Stationery.

31.3
design firm Foreshock
designer Gary Zdeneck
client PSP Direct
logo for Mortgage broker.

31.4
design firm Stewart Monderer Design, Inc.
designer Aime Lecusay
art director Stewart Monderer
client Crescent Networks, Inc.
logo for Identity.

30.1

30.2

30.3

TWO THOUSAND

31.1

GNIBUS
PUBLIC RELATIONS

31.2

PSP DIRECT
prime / sub-prime

31.3

CRESCENT
networks

31.4

MENLO REALTY

32.1

ORBA

32.2

PRIME COMPANIES, INC.

32.3

creative solutions group

32.4

32.1
design firm Wolfback Design
designer Karin Scholz
client Menlo Realty
logo for Realtor.

32.2
design firm Zamboo
art director Becca Bootes
client ORBA Financial Management
logo for Corporate identity.

32.3
design firm Lamfers & Associates
designer Missy Nery
art director Debra Lamfers
client Prime Companies, Inc.
logo for Company identity and applications. PCI invests in and provides management to emerging new technology firms.

32.4
design firm Zamboo
designer Becca Bootes
client Creative Solutions Group
logo for Corporate identity.

33.1
design firm David Carter Graphic Design
designer Tabitha Bogard
art director Lori Wilson
client Mandalay Bay Resort and Casino
logo for Pearl Moon Boutique/Las Vegas, Nevada.

33.2
design firm Kevin Akers Designs
designer Kevin Akers
client Aurea
logo for Cordless/wireless headset product.

PEARL MOON
BOUTIQUE

33.1

AUREA

33.2

NICHOLS
CONCRETE CUTTING

34.1

KARAHADIAN

——————

GENERAL DENTISTRY

34.2

DEL VALLE
COMMUNICATIONS

34.3

CALIFORNIA
ACADEMY
OF
SCIENCES

34.4

EFFICIENT
Capital Management, LLC

34.5

EXTROVERT

35.1

35.2

XyEnterprise™

35.3

34.1
design firm Earlywine Design
designer Terry Earlywine
client Nichols Concrete Cutting
logo for Company identity, trucks, stationery.

34.2
design firm MJR Associates
designer Frank Ruiz
client Edward & Kari Karahadian, DDS
logo for Corporate identity used on stationery, sig-
 nage and marketing materials.

34.3
design firm Alexander Atkins Design
designer Alexander Atkins
client Del Valle Communications
logo for Company specializing in corporate commu-
 nications.

34.4
design firm Primo Angeli Inc.
designer Kelson Mau
art director Rich Scheve
client California Academy of Sciences
logo for All uses.

34.5
design firm ComCorp, Inc.
designer Marnie Breen
art director Abby Miesen
client Efficient Capital Management
logo for Corporate material.

35.1
design firm Miriello Grafico, Inc.
designer Liz Bernal
client Extrovert

35.2
design firm Bruce Yelaska Design
designer Bruce Yelaska
client Simmons, Ungar, Helbush, Steinbert &
 Bright
logo for Immigration law firm.

35.3
design firm Stewart Monderer Design, Inc.
designer Stewart Monderer
client Xyvision Enterprise Solutions, Inc.
logo for Identity.

36.1

36.2

36.3

36.1
design firm Sandy Gin Design
designer Sandy Gin
client BlinkingOwl.com
logo for An on-line shopping comparison site target-
 ing college students.

36.2
design firm Tharp Did It
designers Rick Tharp, Jana Heer
client Bayshore Press
logo for An environmentally responsible printer on
 the West Coast.

36.3
design firm Juddesign
designer Geoff Ledet
art director Patti Judd
client McMillin Company—Calavera Hills
logo for Residential real estate development.

37.1
design firm MJR Associates
designer Frank Ruiz
client Riverbend Golf Club
logo for Corporate identity used on stationery, sig-
 nage, vehicles and marketing materials.

37.2
design firm The Wecker Group
designer Robert Wecker
client California Insurance Group

37.3
design firm American Film Institute
designer Logo Doctor
art directors Tim Clark, Teri Klass
illustrator Tim Clark
client AFI
logo for Identity.

37.1

37.2

AMERICAN FILM INSTITUTE

37.3

DOUBLE EAGLE

GOLF CENTER

38.1

Cypress Avenue

Baptist Church

38.2

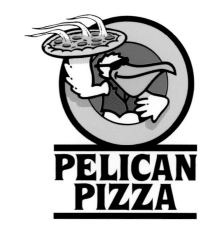

38.1
design firm Conover
designer Melissa Fraser
art director David Conover
client Double Eagle
logo for Golf center.

38.2
design firm Leeson Design
designer Susan Leeson
client Cypress Avenue Baptist Church
logo for Community Christian church.

39.1
design firm The Wecker Group
designer Robert Wecker
client Pelican Pizza
logo for Signage, stationery, packaging, forms.

39.1

39.2
design firm Deluxe Brand
designer Tor Naerheim
client Dimp Wear
logo for Line of clothing.

39.2

39.3
design firm Shields Design
designer Charles Shields
illustrator Doug Hansen
client Investment products catalog/store.

39.3

40.1

40.2

40.1
design firm GDS Studio
designer Gary Solomon
client GDS Studio
logo for On the Mark, a book compiled of logo designs with background of the development of each mark.

40.2
design firm Zamboo
art director Dave Zambotti
client Baton Records
logo for Record label corporate identity.

40.3
design firm Curry Design Associates
designer Joy Rubin
art director Steve Curry
lient Usernet
logo for Electronic convention.

41.1
design firm Kevin Akers Designs
designer Kevin Akers
client San Francisco Symphony
logo for T-shirt graphic for SFS/members of the Grateful Dead concert.

41.2
design firm Vigon/Ellis
designer Brian Jackson
art director Larry Vigon
client Cyber Media
logo for Corporate identity.

40.3

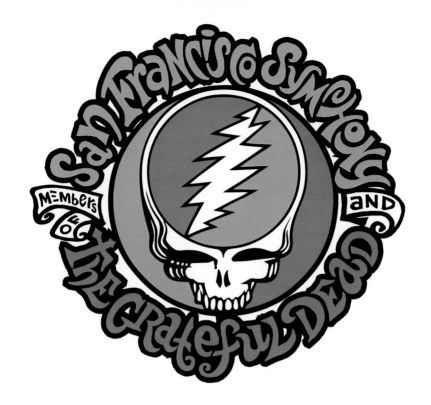

41.1

CYBERMEDIA

MORE POWER TO YOU

41.2

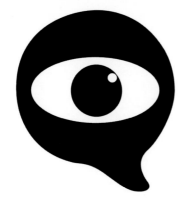

42.1

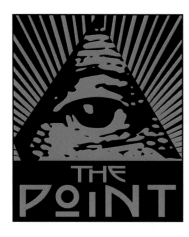

42.2

42.3

42.1
design firm | Fuse
designer | Russell Pierce
client | PairGain (Avidia IQ)
logo for | Product logo, used on packaging and literature.

42.2
design firm | LF Banks + Associates
designer | John German
art director | Lori F. Banks
client | The Point
logo for | Identity image for coffeehouse and concert venue.

42.3
design firm | Taber Integrative Design
designer | Barbara Hennelly
art director | Michele Taber
client | ChannneLogic
logo for | An identity for a company that assesses profitability in "Fortune 100" company channel partnerships.

43.1
design firm | Moonlight Design
designer | Karen Ryan
client | Visionsound Productions
logo for | Audio and video post-production house.

43.2
design firm | Pierre Rademaker Design
designers | Pierre Rademaker, Kandy David
client | Blake Printery
logo for | Print items, forms, signage, vehicles, uniforms, shipping containers, collateral.

43.3
design firm | The Wecker Group
designer | Robert Wecker
client | Denise Matta
logo for | Stationery.

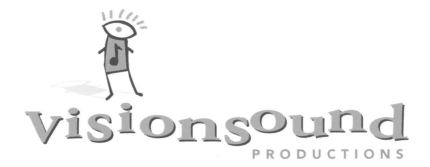

43.1

43.2

DENISE MATTA

PHOTOGRAPHY/ILLUSTRATION/GRAPHIC DESIGN

43.3

44.1
design firm	John Champ Design Associates
designer	Randall Cohen
client	Permagrin
logo for	Corporate identity.

44.2
design firm	Kevin Akers Designs
designer	Kevin Akers
client	eQuaint.com
logo for	Software company.

44.3
design firm	Vigon/Ellis
designers	Marissa Galang, Brian Jackson
art director	Larry Vigon
client	Interven Partners
logo for	Corporate identity.

45.1
design firm	VWA Group
designer	Rhonda Warren
client	Los Piratas
logo for	Children's Center for luxury resort.

45.2
design firm	Kevin Akers Designs
designer	Kevin Akers
client	Bank Street
logo for	Clothing boutique.

45.3
design firm	Kevin Akers Designs
designer	Kevin Akers
client	Suissa Beauty Company
logo for	Beauty products and packaging.

45.4
design firm	LF Banks + Associates
designer	John German
art director	Lori F. Banks
client	Center for Greater Philadelphia
logo for	Identity image for non-profit public policy organization.

45.5
design firm	Focus Design
designer	Brian Jacobson
client	Black & Co.
logo for	Corporate identity.

44.1

eQuaint.com

44.2

INTERVEN

PARTNERS

44.3

Los Piratas

45.1

45.2

45.3

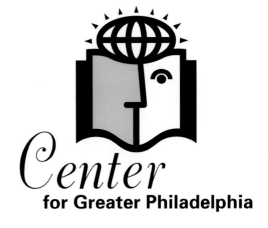

45.4

Building Brands *With Personality*

45.5

TamalpaisBank

46.1

46.2

46.3

46.1
design firm Mortensen Design
designer Wendy Chon
art director Gordon Mortensen
client Tamalpais Bank
logo for The bank.

46.2
design firm Engle + Murphy
designer Robin Seaman
client OnCall Healthcare Communications
logo for Identity for company that provides demand management services to physicians and their patients by telephone.

46.3
design firm Focus Design
designers Brian Jacobson, Gustavo Alcantar
art director Brian Jacobson
illustrator Gustavo Alcantar
client Inference Corporation
logo for Event identity.

47.1
design firm MJR Associates
designer Frank Ruiz
client Peter S. Levin MD
logo for Corporate identity used on stationery, signage and marketing materials.

47.2
design firm Alexander Atkins Design, Inc.
designer Alexander Atkins
client Lindstrom Represents
logo for Company representing artists.

47.3
design firm Alexander Atkins Design, Inc.
designer Alexander Atkins
client Stanford University
logo for Women's conference focusing on business issues.

47.04
design firm David Carter Graphic Design
designer Emily Cain
art director Lori Wilson
client Disney Cruise Line
logo for Common Grounds.

Peter S. Levin, M.D.

Ophthalmic and Facial Plastic Surgery

47.1

47.2

GSB WOMEN
WORKING
TOWARD
SOLUTIONS

47.3

47.4

OH BOY, A DESIGN COMPANY

5pm - 9am ®

OH BOY, A DESIGN COMPANY

Est. 1994 ®

Annual Reports

OH BOY, A DESIGN COMPANY

Est. 1994 ®

Advertising

OH BOY, A DESIGN COMPANY

Est. 1994 ®

Happy Holidays from

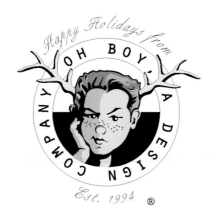

OH BOY, A DESIGN COMPANY

Est. 1994 ®

Branding and Identity

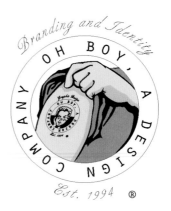

OH BOY, A DESIGN COMPANY

Est. 1994 ®

48.1

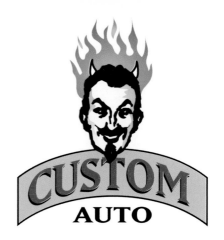

49.1

48.1
design firm Oh Boy, A Design Company
designer Hunter L. Wimmer
art director David Salanitro
client Oh Boy, A Design Company
logo for Self-promotion, business papers.

49.1
design firm Solution 111 Design
designer Darryl Glass
client Custom Auto
logo for Signage, stationery, van for auto shop that
 builds custom cars and engines.

49.2
design firm Dutch Design
designer Rick Smits
client Dutch Design
logo for Self-promotion.

49.3
design firm Sandy Gin Design
designer Sandy Gin
client Sony Signatures
logo for Proposed logo for a band.

49.2

49.3

50.1

50.2

50.3

50.4

50.1
design firm Deluxe
designer Tor Naerheim
client Deluxe Brand
logo for In-house Deluxe Brand identity.

50.2
design firm GDS Studio
designer Gary Solomon
client The Creative Department.com
logo for Image identity, stationery, website, T-shirts.

50.3
design firm Sandy Gin Design
designer Sandy Gin
client Campusworks
logo for An on-line textbook retailer.

50.4
design firm Engle + Murphy
designer Enily Moe
client WisePlace
logo for Corporate ID for organization that provides
 transitional services to homeless women.

51.1
design firm The Huge Idea
designer Lesli Wuco-B
client Etudes
logo for Distance education website.

51.2
design firm Vigon/Ellis
designer Marc Yeh
art director Larry Vigon
client BrainCo
logo for Corporate identity.

51.3
design firm Kevin Akers Designs
designer Kevin Akers
client Kids Cuts
logo for Children's hair cutting salon.

É T U D E S

51.1

51.2

51.3

★
51

DIGITAL COLOR SYSTEMS

52.1

COLOR WORKS
DIGITAL IMAGING CENTER

52.2

MATCHFRAME

52.3

52.1
design firm Juddesign
designers Hal Maynerd, Eric Watanabe
art director Patti Judd
client Digital Color Systems
logo for Full service color house.

52.2
design firm Evolution Design
art director Bear Files
client Color Works
logo for Corporate identity for a color copy house in
 San Diego.

52.3
design firm Boardwalk
designer Harriet Breitborde
client Match Frame
logo for Marketing, promotion, signage.

53.1
design firm Moonlight Design
designer Karen Ryan
art director David Ryer
client Movietown.com
logo for Parent corporation of website selling
 VHS & DVD movies.

53.2
design firm The Wecker Group
designer Robert Wecker
client Delta Point, Inc.
logo for Packaging.

53.3
design firm Focus Design
designer Brian Jacobson
client Spectrum Photographic & Images
logo for Corporate identity.

53.4
design firm Zamboo
designer Dave Zambotti
client Z Filmmaker
logo for Independent film editor.

53.5
design firm Klass Design
designer Logo Doctor
illustrator Teri Klass
client Title House
logo for Proposed identity for a production house in
 Los Angeles.

53.6
design firm Michael Osborne Design
designer Paul Kagiwada
art director Michael Osborne
client Kelmscott Communications
logo for Printer.

53.1

53.2

53.3

53.4

53.5

53.6

54.1

54.2

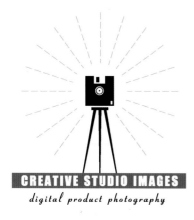

54.3

54.4

PAPPAS|TELEPRODUCTIONS

54.5

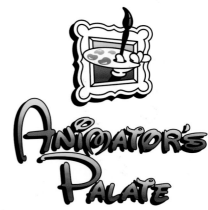

54.1
design firm Kevin Akers Designs
designer Kevin Akers
client Elapse Photo
logo for Film/photo developing store.

54.2
design firm Shields Design
designer Charles Shields
illustrator Phil Rudy
client Phil Rudy Photography
logo for Photographer.

54.3
design firm Jon Briggs Design
designer Jon Briggs
client Creative Studio Images
logo for Conveying company's identity and capabilities in the field of digital product photography.

54.4
design firm Akers Designs
designer Kevin Akers
client Friends of Photography
logo for Golf tournament.

54.5
design firm MJR Associates
designer Frank Ruiz
client Pappas Teleproductions
logo for Corporate identity used on stationery, signage and marketing materials.

55.1
design firm David Carter Graphic Design
designer Rickey Brown
art director Lori Wilson
client Disney Cruise Line
logo for Animator's Palate.

55.2
design firm Kevin Akers Designs
designer Kevin Akers
client Sharpe Models
logo for Talent agency.

55.3
design firm Fuse
designer Russell Pierce
client Joe Photo
logo for Corporate identity/brand.

55.1

55.2

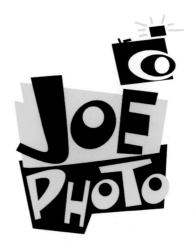

55.3

C / L / B

56.1

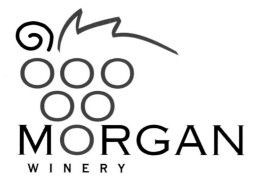

56.2

56.3

56.1
design firm Susan Meshberg Graphic Design
designer Susan Meshberg
illustrators Elaine MacFarlane, Jia Hwang
client Chateau Los Boldos
logo for Trademark/identity for Chateau Los Boldos,
 a Chilean winery.

56.2
design firm The Wecker Group
designer Robert Wecker
client Morgan Winery
logo for Labels, packaging, stationery.

56.3
design firm The Wecker Group
designer Robert Wecker
client Morgan Winery
logo for Alternate logo.

57.1
design firm The Wecker Group
designer Robert Wecker
client Valeria Winery
logo for Packaging.

57.2
design firm Jason Graham
designer Jason Graham
client La Bella Luna
logo for Northern Italian Cuisine with an extensive
 wine list, accompanied by a romantic
 atmosphere.

57.3
design firm Kevin Akers Designs
designer Kevin Akers
client Judee inc.
logo for Holiday party.

57.4
design firm David Carter Graphic Design
designer Gary LoBue
art director Lori Wilson
client Disney Cruise Line
logo for Palo.

57.1

57.2

57.3

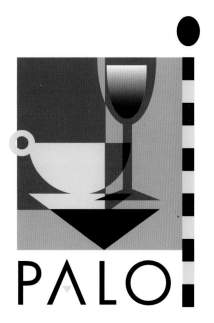

57.4

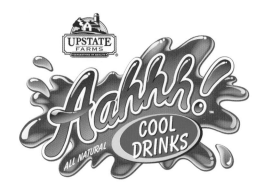

58.1

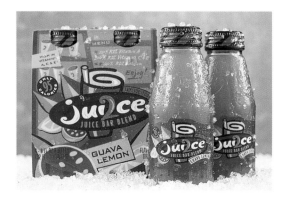

58.2

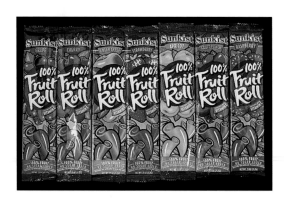

58.3

58.1

design firm	McElveney & Palozzi Design Group, Inc.
designer	Ellen Johnson
art directors	William McElveney, Steve Palozzi
client	Upstate Farms, Inc.
logo for	Beverage labels, P.O.P. displays and banners.

58.2

design firm	Primo Angeli Inc.
designers	Sarah Sandstrom, Sandy Russell
art director	Rich Scheve
client	Crystal Geyser Water Company
logo for	Jui2ce.

58.3

design firm	Primo Angeli Inc.
designers	Harumi Kubo, Koji Miyaki
art directors	Rich Scheve
client	Paramount Farms
logo for	Fruit Rolls.

59.1

design firm	The Wecker Group
designer	Robert Wecker
client	Café Au Lait Restaurant
logo for	Signage, stationery.

59.2

design firm	Blanco Design
designer	Shelly Blanco
client	Mother Mudd's Coffee

59.3

design firm	David Carter Graphic Design
designer	Tien Pham
art director	Lori Wilson
logo for	Sushi Sake

59.4

design firm	Alexander Atkins Design, Inc.
designer	Alexander Atkins
client	Skinny Sippin
logo for	Upscale fruit juice retailer.

59.5

design firm	Kevin Akers Designs
designer	Kevin Akers
client	Baskin Robbins
logo for	Internal team-building seminar.

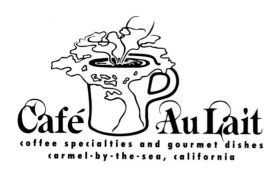

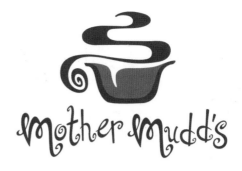

59.1

59.2

59.3

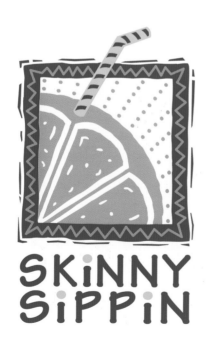

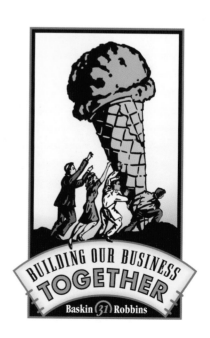

59.4

59.5

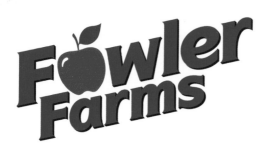

60.1

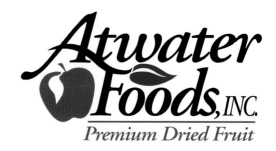

60.2

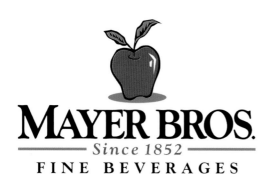

60.3

60.4

60.5

61.1

60.1

design firm	McElveney & Palozzi Design Group, Inc.
designer	Jan Marie Gallagher
art directors	William McElveney, Matt Nowicki
client	Fowler Farms
logo for	Letterhead, business cards, envelopes.

60.2

design firm	McElveney & Palozzi Design Group, Inc.
art directors	William McElveney, Lisa Williamson
client	Atwater Foods, Inc.
logo for	Letterhead, business cards, envelopes, brochure, sell sheets, website.

60.3

design firm	McElveney & Palozzi Design Group, Inc.
art director	William McElveney, Lisa Parenti
client	Mayer Bros.
logo for	Beverage labels, sell sheets, containment folder.

60.4

design firm	MJR Associates
designer	Frank Ruiz
client	Greene & Hemly
logo for	Corporate identity used on stationery, signage and marketing materials.

60.5

design firm	Stone Yamashita
designer	Jennifer Olsen
client	David Binder Productions
logo for	Theater producer in New York.

61.2

61.1

design firm	Karen Mehoff & Co.
designer	Karen Mehoff
client	Apple Mountain Pie Company
logo for	Identity for a home-baked pie company.

61.2

design firm	Juddesign
designers	Rosemary Rae, Karen Winward
art director	Patti Judd
client	California Avocado Category Marketing
logo for	Avocado industry marketing association.

61.3

design firm	Sandy Gin Design
designer	Sandy Gin
client	it's all good
logo for	An upscale catering company.

61.3

62.1

STEWS & CHILI TOO

62.2

62.1
design firm Bryan Friel Studio
designer Bryan Friel
client Just Soup
logo for Signage, menus, ads.

62.2
design firm The Wecker Group
designer Robert Wecker
client Caffe Cardinale
logo for T-shirts, posters.

63.1
design firm Leeson Design
designer Susan Leeson
client BBQ Buddies
logo for A barbecue retail company that
sells utensils, sauce, and everything
else for the grill.

63.2
design firm Dutch Design
designer Rick Smits
client Lansing Christian School
logo for T-shirts and flyers.

63.3
design firm Allen Orr
designer Allen Orr
client Spud's Lounge

63.1

63.2

63.3

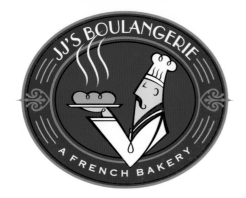

64.1

64.2

64.3

64.1
design firm David Carter Graphic Design
designer Tien Pham
art director Lori Wilson
client Paris Resort and Casino
logo for JJ's Boulangerie/Las Vegas, Nevada.

64.2
design firm Taber Integrative Design
designer Michele Taber
client A Catered Affair: Hoagies Food & Beverage
logo for The catering division of Hoagies Food &
 Beverage Corp. serving the Silicon Valley.

64.3
design firm Lamfers & Associates
designer Debra Lamfers
illustrator Rose Cassano
client Jessie et Laurent Culinary Service
logo for Company identity—applied to print, signage
 and electronic media.

65.1
design firm David Carter Graphic Design
designer Emily Cain
art director Lori Wilson
client Portifino Bay Hotel
logo for Splendido Pizzeria/Orlando, Florida.

65.2
design firm The Wecker Group
designer Robert Wecker
client California Restaurant Association
logo for Stationery.

65.3
design firm Wallace Church Associates, Inc.
designer Wendy Church
illustrator Tracy Sabin
client Mazola
logo for Mazola pro chef cooking spray.

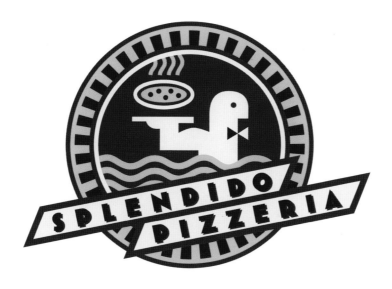

65.1

CALIFORNIA
RESTAURANT
ASSOCIATION
EDUCATIONAL
FOUNDATION

65.2

65.3

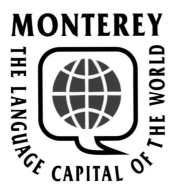

66.1

BUSINESS GROUPS

66.2

EARTH ISLAND

INSTITUTE

66.3

66.1
design firm The Wecker Group
designer Robert Wecker
client City of Monterey
logo for Signage, stationery, collateral.

66.2
design firm McElveney & Palozzi Design Group, Inc.
art directors William McElveney, Jon Westfall
client CPI Business Groups
logo for Letterhead, business cards, envelopes,
 brochure.

66.3
design firm Elixir Design
designer Nathan Durrant
art director Jennifer Jerde
illustrator Nathan Durrant
client Earth Island Institute
logo for Non-profit environmental organization
 acting as an incubator for projects
 promoting conservation, preservation,
 and restoration of the earth.

67.1
design firm GDS Studio
designer Gary Solomon
client Daniels Financial Services
logo for Stationery system and press kit.

67.2
design firm Shields Design
designer Charles Shields
client Main Street Trading Company
logo for Investments company.

67.3
design firm Stoyan Design
designer Michael Stinson
art director David Wooters
illustrator Michael Stinson
client Cytovia

67.4
design firm Focus Design
designer Brian Jacobson
client Ösel Incorporated
logo for Corporate identity.

67.5
design firm Stoyan Design
designer Michael Stinson
client Global Technology Distribution Council

67.6
design firm The Wecker Group
designer Robert Wecker
client The Wecker Group
logo for Signage, stationery, forms.

67.1

67.2

67.3

67.4

67.5

67.6

GLOBAL WEB
TEAMWORK

68.1

68.2

68.3

68.1
design firm Solution 111 Design
designer Darryl Glass
client Global Web
logo for Advertising for a website developer and host.

68.2
design firm Fuse
designer Russell Pierce
client PairGain (Open Planet)
logo for Promotional program, used in advertising and signage.

68.3
design firm Sandy Gin Design
designer Sandy Gin
client Origin Medsystems
logo for An in-house use at a medical device company.

69.1
design firm Moonlight Design
designer David Ryer
client Sci-Fi Universe Magazine
logo for Annual awards honoring science fiction books, films, TV, etc.

69.2
design firm McElveney & Palozzi Design Group, Inc.
art directors Steve Palozzi, Jon Westfall
client Auto-Soft
logo for Brochure, sell sheets, software packaging for Material Control Rx.

69.3
design firm Moonlight Design
designer David Ryer
client WorldTel
logo for Company selling prepaid phone service cards.

69.4
design firm The Wecker Group
designer Robert Wecker
client Monterey Network Center
logo for Signage, stationery, collateral.

69.5
design firm McElveney & Palozzi Design Group, Inc.
designer Dillon Constable
art directors William McElveney, Matt Nowicki
client G-Force Collaborations
logo for Letterhead, business cards, envelopes.

69.6
design firm The Wecker Group
designer Robert Wecker
client OnLine Interpreters
logo for Signage, stationery, forms, collateral.

69.1

69.2

69.3

MONTEREY NETWORK CENTER

69.4

69.5

69.6

70.1

SAN FRANCISCO SYMPHONY

70.2

70.3

70.1
design firm	Lewis Design
art director	June Lewis
illustrator	Tracy Sabin
client	Kidcare Express
logo for	Healthcare informational bus for public schools.

70.2
design firm	Kevin Akers Designs
designer	Kevin Akers
client	San Francisco Symphony
logo for	New Year's Eve 2000 gala concert.

70.3
design firm	Shields Design
designer	Laura Thornton
art director	Charles Shields
client	Children's Hospital
logo for	Hospital program.

71.1
design firm	ComCorp, Inc.
designer	ComCorp Staff
art director	George Kubricht
client	Kartoon Kingdom
logo for	Retail marketing collateral.

71.2
design firm	Sandy Gin Design
designer	Sandy Gin
client	Fila Footwear
logo for	Proposed logo for use on clothing line.

71.3
design firm	Mike Salisbury Communications
art director	Mike Salisbury
illustrator	Dave Parmely
client	Paramount
logo for	Phantom.

71.4
design firm	The Wecker Group
designer	Robert Wecker
client	Hot Wax Media
logo for	Stationery.

71.5
design firm	BobCo Design Inc.
designer	Robert S. Nenninger
client	Bandai America
logo for	Packaging for a line of pocket-sized toys called "Virtual Pets." These toys started a revolution.

71.6
design firm	BobCo Design Inc.
designer	Robert S. Nenninger
client	Bandai America
logo for	Packaging for a line of "Virtual Pet" toys that are connected together to battle each other.

71.1

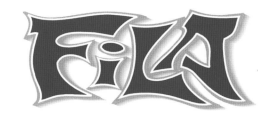

71.2

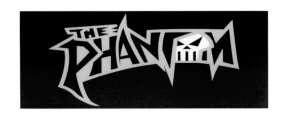

71.3

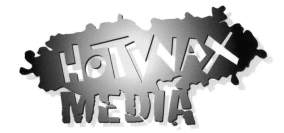

71.4

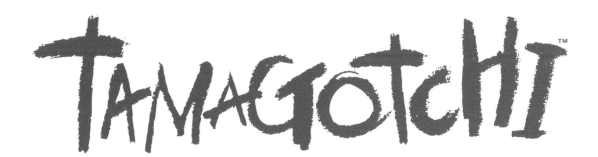

71.5

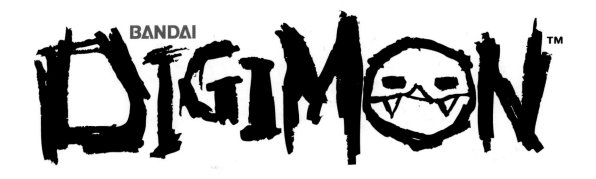

71.6

Adamm's

STAINED GLASS & AMERICAN CRAFT GALLERY

72.1

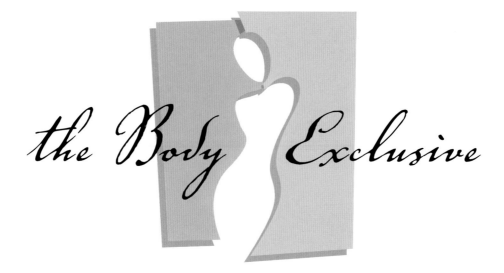

the Body Exclusive

72.2

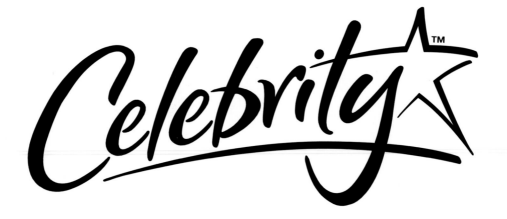

Celebrity™

72.3

73.1

72.1
design firm	Innovative Design and Advertising
designers	Susan Nickey-Newton, Kim Crossett-Neumann
illustrator	Dan Cotton
client	Adamm's Stained Glass
logo for	Signage, business cards, letterhead, gift bags.

72.2
design firm	Vigon/Ellis
designer	Brian Jackson
art director	Larry Vigon
client	Body Exclusive
logo for	Corporate identity.

72.3
design firm	The Marketing Store
designer	Kevin Wilhelm
client	Altaireyewear
logo for	Celebrity eyewear.

73.2

75.1
design firm	Jeffry Hipp
designer	Jeffry Hipp
client	National Ford Tool Collectors
logo for	National club for collectors of Ford automobile tools. Identity system.

73.2
design firm	Mike Salisbury Communications
designers	Mike Salisbury, Brian Sisson
art director	Dave Willardson
illustrator	Bob Maile
client	Hasbro

73.3

73.3
design firm	Stephgrafx
designer	Stephanie Payan
client	Talking Hearts Press
logo for	Book publisher and public speaker.

73.4
design firm	Primo Angeli Inc.
designers	Terrence Tong, Oscar Mulder
art director	Jennifer Bethke
client	Sara Lee
logo for	Sara Lee.

73.4

THE *Paragon* FOUNDATION

74.1

74.2

Walter Dyer's

SHOES & LEATHER

74.3

74.4

74.5

74.1
design firm Juddesign
designer Eric Watanabe
art director Patti Judd
client The Paragon Foundation
logo for Mission value management organization.

74.2
design firm GDS Studio
designer Gary Solomon
client Vivitar Corporation
logo for Ad campaign and point-of-purchase for home
 digital art studio, promoting digital camera,
 scanner, printer for the whole family.

74.3
design firm McElveney & Palozzi Design Group, Inc.
designer Paul Reisinger, Jr.
art director Matt Nowicki
client Walter Dyer's Shoes & Leather
logo for Direct mail pieces.

74.4
design firm Minka Willig Design
designer Minka Willig
xclient Flower Hill Flowers
logo for Flower shop identity system.

74.5
design firm Eve Vrla Design
designer Eve Vrla
client Lauren Meyer Communications, Inc.
logo for Corporate identity event planning and
 marketing firm.

75.1
design firm Conover
designer Melissa Fraser
art director David Conover
client Shea Homes
logo for Residential home development.

75.2
design firm Portal Publications
designer Mabel Shiue
art director Gary Higgins
client Portal Publications
logo for A greeting card line called "wise little
 souls" to send the message that our chil-
 dren, perfect from birth, are both our stu-
 dents and our teachers.

5.3
design firm VWA Group
designer Brian Blankenship
art director Rhonda Warren
client Jefferson Property, Inc.
logo for Identity, letterhead, brochure, advertise-
 ments for Jefferson at LaValencia.

75.1

75.2

75.3

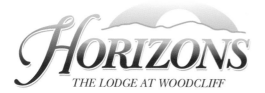

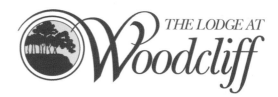

76.1

76.2

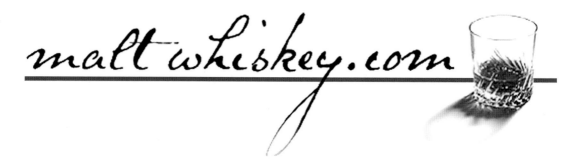

76.3

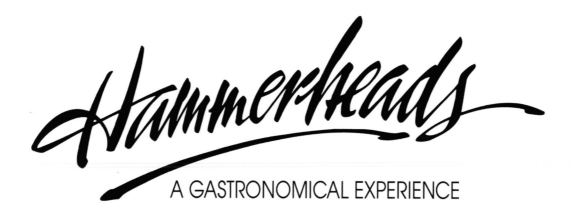

A GASTRONOMICAL EXPERIENCE

76.4

76.1
design firm McElveney & Palozzi Design Group, Inc.
art directors William McElveney, Ellen Johnson
client The Lodge at Woodcliff
logo for Horizons restaurant menus.

76.2
design firm McElveney & Palozzi Design Group, Inc.
art directors William McElveney, Ellen Johnson
client The Lodge at Woodcliff
logo for Letterhead, business cards, envelopes,
 brochure, signage.

6.3
design firm Shields Design
designer Charles Shields
illustrator Camerad
client Malt Whiskey.com
logo for Website.

76.4
design firm The Wecker Group
designers Robert Wecker, Mark Savee
client Hammerheads Restaurant
logo for Signage, menus, specialty advertising.

77.1
design firm Curry Design Associates
designer Jason Scheideman
client Curioso
logo for Specialty boutique store.

77.2
design firm Klass Design
designer Logo Doctor
art director Teri Klass
illustrator Tim Clark
client Optimism
logo for Identity for a fragrance company.

77.3
design firm David Carter Graphic Design
designer Tabitha Bogard
art director Lori Wilson
client Paris Resort and Casino
logo for Du Parc/Las Vegas, Nevada.

77.4
design firm David Carter Graphic Design
designer Sharon LeJeune
art director Lori Wilson
client Mandalay Bay Resort and Casino
logo for Shanghai Lilly/Las Vegas, Nevada.

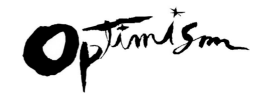

77.1

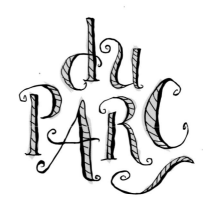

77.2

77.3

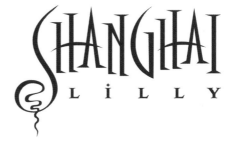

77.4

78.1
design firm M Studio
designer Mabel Shiue
client Blow Fish-Sushi To Die For
logo for A cutting-edge restaurant with focus on bar, sushi and loud music.

78.2
design firm Klass Design
designer Logo Doctor
art director Stephen Noriega
illustrator Teri Klass
client Cava Restaurant
logo for Identity for a night club.

78.3
design firm The Wecker Group
designer Robert Wecker
client Kazu Public Radio
logo for Wine tasting fund raiser, programs.

79.1
design firm MJR Associates
designer Aimee McKirdy
art director Frank Ruiz
client California Sprouts
logo for Corporate identity used on stationery, signage and marketing materials.

79.2
design firm Innovative Design and Advertising
designers Susan Nickey-Newton, Kim Crossett-Neumann
client Markie D's Restaurant
logo for Signage, flyers, menus, business cards, ads, etc.

79.3
design firm The Wecker Group
designer James Kyllo
art director Robert Wecker
client McAbee Beach Cafe
logo for Signage, menus, stationery, specialty advertising.

79.4
design firm The Wecker Group
designers Ruth Minerva, Craig Rader
art director Robert Wecker
client Michael's Restaurant
logo for Signage, stationery.

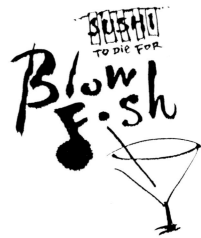

78.1

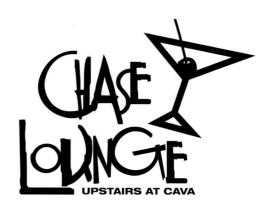

78.2

78.3

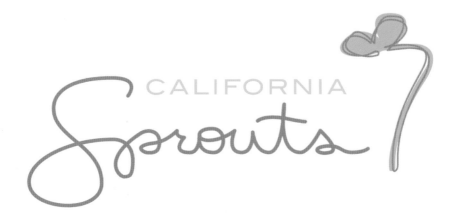

79.1

79.2

79.3

79.4

80.1

80.2

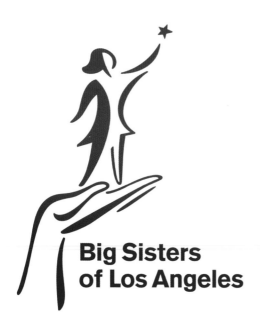

80.3

80.1
design firm Kevin Akers Designs
designer Kevin Akers
client Kenwood Group
logo for Conference graphic.

80.2
design firm Tom Fowler, Inc.
designer Karl S. Maruyama
client St. Luke's LifeWorks
logo for An annual report whose theme was
 "What it takes to build a home."

80.3
design firm Zamboo
designer Dave Zambotti
client Big Sisters of Los Angeles
logo for Corporate identity.

81.1
design firm Focus Design
designers Brian Jacobson, Creighton Dinsmore
client Inference and Cybergold
logo for Special incentive program.

81.2
design firm Seaman Design Group/Sheppard & Assoc.
designer Robin Seaman
client Apple Computer, Inc.
logo for Their Environmental Health and Safety
 Program that encourages sound procedures,
 healthy living and safe working practices.

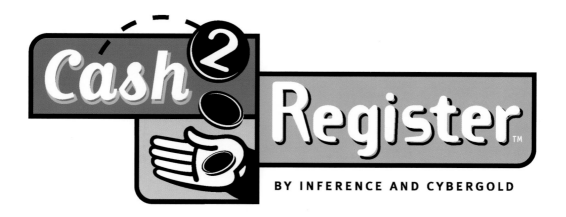

BY INFERENCE AND CYBERGOLD

81.1

81.2

82.1

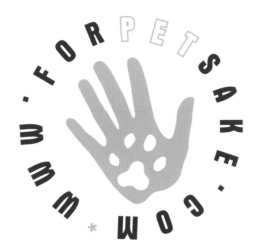

82.2

82.3

82.1
design firm Seaman Design Group
designer Robin Seaman
client The California Endowment
logo for A philanthropic foundation whose mission is
 to expand access to affordable, quality
 health care for the underserved communi-
 ties of California.

82.2
design firm The Huge Idea
designer Lesli Wuco-B
client For Pets' Sake.com
logo for Company/Website.

82.3
design firm Tom Fowler, Inc.
designer Thomas G. Fowler
client Ross Products Division/Abbott Laboratories
logo for Creating a cohesive look to all the various
 resource materials and services Ross
 Products provides the pediatrics nursing
 industry.

83.1
design firm Vigon/Ellis
designer Brian Jackson
art director Larry Vigon
client Enfish Technology Inc.
logo for Corporate identity.

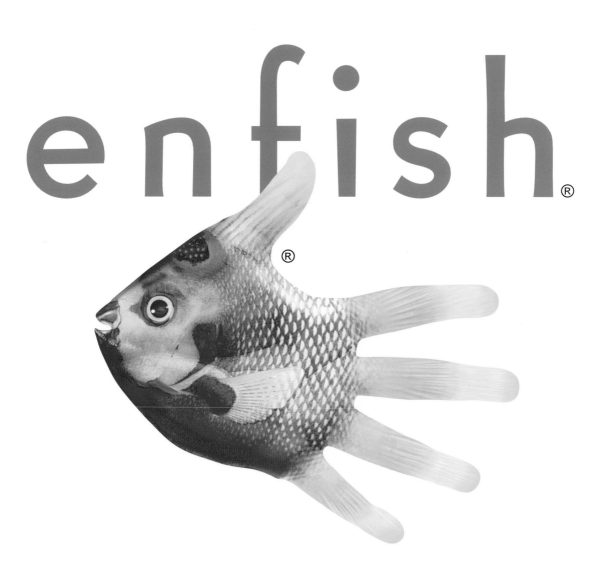

83.1

Conner's Cause
for Children

84.1

84.2

84.1
design firm John Champ Design Associates
designer Randall Cohen
art director John Champ
client Conner's Cause for Children
logo for Non-profit organization's identity.

84.2
design firm Wolfback Design
designer Karin Scholz
client Stephen Miller Gallery
logo for Oriental rug gallery.

84.3
design firm Blanco Design
designer Shelly Blanco
client Friends of Signal Hill Cultural Arts

85.1
design firm Kevin Akers Designs
designer Kevin Akers
client Western Arts Alliance
logo for Entertainment promoter—family of logos
developed for conference topics.

FRIENDS
of
SIGNAL HILL
CULTURAL ARTS

84.3

85.1

★
85

Art Therapy Institute
OF SAN FRANCISCO

86.1

WOMEN ACROSS GENERATIONS
...A Volunteer Resource

86.2

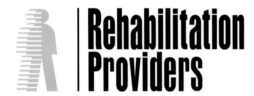

86.3

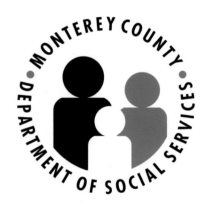

86.4

C A B R I N I - G R E E N
Tutoring Program, Inc.

86.5

health quarters

87.1

87.2

EQUAL ACCESS
To The Law

86.1
design firm Lamfers & Associates
designer Debra Lamfers
illustrator Linda Chapman
client Art Therapy Institute
logo for Company identity and applications. Art Therapy Institute helps children through art therapy and teaches medical professionals these skills.

86.2
design firm Benita Oberg Design
designer Benita Oberg
client Women Across Generations
logo for Stationery, collateral, web.

86.3
design firm The Wecker Group
designer Robert Wecker
client Rehabilitation Providers
logo for Signage, stationery, forms.

86.4
design firm The Wecker Group
designer Robert Wecker
client Monterey County Department of Social Services
logo for Stationery, signage.

86.5
design firm ComCorp, Inc.
designer Abby Mines
client Cabrini-Green Tutoring Program
logo for Corporate material and volunteer material.

87.1
design firm Stewart Monderer Design, Inc.
designer Stewart Monderer
client Health Quarters
logo for Identity.

87.2
design firm Lorenz
designer Arne Ratermanis
client Teen Life Choice
logo for Identity for a non-profit organization.

87.3
design firm J. Robert Faulkner Advertising
designer J. Robert Faulkner
client Equal Access

87.3

FRIEDLAND JACOBS

COMMUNICATIONS

88.1

RED BOY GEAR

88.2

CAM
SERVICES
COMMON AREA
MAINTENANCE

88.3

88.1
design firm Vigon/Ellis
designer Brian Jackson
art director Larry Vigon
client Friedland Jacobs Communications
logo for Corporate identity.

88.2
design firm Solution 111 Design
designer Darryl Glass
client Red Boy Gear
logo for Labels, sales tags and stationery for Red
 Boy Gear, a clothing manufacturer.

88.3
design firm Klass Design
designer Logo Doctor
illustrator Teri Klass
client CAM Services
logo for Identity for a maintenance company
 in Los Angeles.

89.1
design firm Klass Design
designer Logo Doctor
art director Teri Klass
illustrator Tim Clark
client Stock Exchange
logo for Identity for a night club in Los Angeles.

89.2
design firm Klass Design
designer Logo Doctor
art directors Tim Clark, Teri Klass
illustrator Teri Klass
client Bad Driver Productions
logo for Identity system for movie production
 company.

89.3
design firm The Gap
designer Logo Doctor
art director Tim Cohrs
illustrator Tim Clark
client The Gap Store
logo for The Gap Rap Magazine website.

89.1

89.2

89.3

90.1

90.2

90.3

90.1
design firm Talbot Design Group
designer Chris Kosman
art director GayLyn Talbot
client MBK- My Brother's Keeper
logo for Identity and collateral (stationery, labels, invitations).

90.2
design firm Juddesign
designer Steve Donegan
art director Patti Judd
client Freedom Carpet Care
logo for Carpet cleaning service.

90.3
design firm Carol Gravelle Graphic Design
designer Carol Gravelle
client Act Networks, Inc.
logo for Company motivational materials.

91.1
design firm Pierre Rademaker Design
designer Pierre Rademaker, Jeff Austin
client Hello Central
logo for Print items, product catalogue.

91.2
design firm Tsuchiya Sloneker Communications, Inc.
designer Colin O'Neill
art director Mark Sloneker
illustrator Colin O'Neill
client Eastman Kodak/Themed Entertainment
logo for Service logo—product packaging.

91.3
design firm Moonlight Design
designer Karen Ryan
art director David Ryer
client CompletePT
logo for Company providing land and aquatic physical therapy and rehab services.

91.4
design firm MJR Associates
designer Frank Ruiz
client Stephen J. Ikemiya DDS
logo for Corporate identity used on stationery, signage and marketing materials.

91.5
design firm Bryan Friel Studio
designer Bryan Friel
client Melanie Crandall & Associates
logo for Stationery, promotional items.

91.1

Kodak

91.2

91.3

Stephen J. Ikemiya, D.D.S.
Restorative, Esthetic and Implant Dentistry

91.4

91.5

92.1

design firm	Mortensen Design
designer	PJ Nidecker
art director	Gordon Mortensen
client	MyPlay, Inc.
logo for	High-tech company.

92.2

design firm	Mortensen Design
designer	PJ Nidecker
art director	Gordon Mortensen
client	Handspring, Inc. (Springboard)
logo for	High-tech company.

92.3

design firm	Mortensen Design
designer	PJ Nidecker
art director	Gordon Mortensen
client	Handspring, Inc.
logo for	High-tech company.

93.1

design firm	Michelle Leshner Designs
designer	Michelle Leshner
illustrator	Lise Dahms
client	Fitness Plus
logo for	Business system and all collateral materials.

93.2

design firm	CTS Design
designer	Claire T. Smith
client	Kitafit
logo for	Fitness videos and company identity.

93.3

design firm	Carol Gravelle Graphic Design
designer	Carol Gravelle
art director	Paddy Farrell-Thomas
illustrator	Carol Gravelle
client	SourceCom
logo for	Product for networking router.

93.4

design firm	Prints of Peach Design Group
designers	Warren Lloyd Dayton, Martha S. Dayton
client	Jerry Blevins
logo for	Letterhead, business card, invoice, for physical fitness trainer.

93.5

design firm	Bryan Friel Studio
designer	Bryan Friel
client	The Sports Club/LA
logo for	Signage, merchandise, corporate literature.

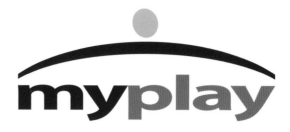

92.1

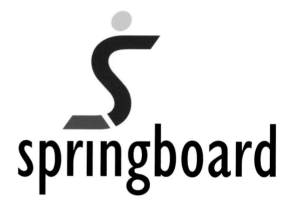

92.2

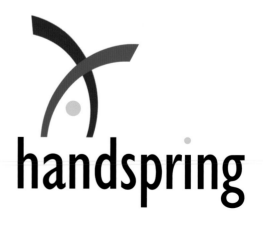

92.3

93.1

defy gravity...

93.2

93.3

93.4

THE SPORTS CLUB/LA

93.5

94.1

94.1
design firm	Carol Gravelle Graphic Design
designer	Carol Gravelle
art director	Barbara Mizuno
illustrator	Carol Gravelle
client	Camelbak
logo for	Product featuring "hands free hydration" possible with Camelbak water system.

94.2
design firm	Earlywine Design
designer	Terry Earlywine
client	Offset Fulfilment Services
logo for	Company identity, stationery, signage.

94.3
design firm	Stewart Monderer Design, Inc.
designer	Aime Lecusay
art director	Stewart Monderer
client	Corporate Communications, Inc.
logo for	Identity.

95.1
design firm	The Huge Idea
designer	Lesli Wuco-B
client	Lesli Wuco-B
logo for	Design studio.

94.2

95.2
design firm	Alexander Atkins Design, Inc.
designer	Alexander Atkins
client	Abbott Usability
logo for	Company that conducts product evaluations.

95.3
design firm	Heart Times Coffee Cup Equals Lighting
designer	Paul Rogers
art director	Bobby Woods
illustrator	Paul Rogers
client	Seed Productions
logo for	Film production company.

95.4
design firm	Shields Design
designer	Juan Vega
art director	Charles Shields
client	Attitude Online
logo for	Internet service provider.

94.3

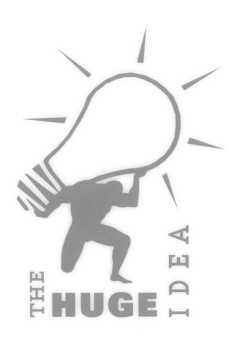

95.1

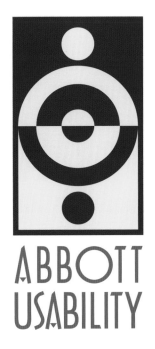

95.2

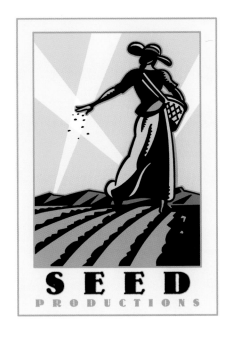

95.3

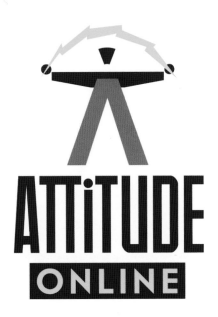

95.4

Black & Blu

E N T E R T A I N M E N T

96.1

MUSIC CITY TICKETS

MUSIC CITY TICKETS

MUSIC CITY TICKETS

96.2

W I N D C A R E

96.3

97.1

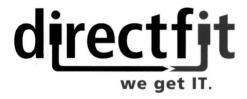

97.2

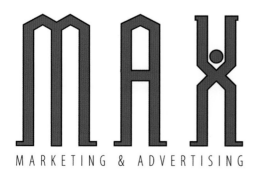

97.3

96.1
design firm	Zamboo
designers	Jeff Allison, Becca Bootes
client	Black & Blu Entertainment
logo for	Corporate identity.

96.2
design firm	Stone Yamashita
designer	Jennifer Olsen
client	City Tickets
logo for	Ticket broker service for all kinds of events.

96.3
design firm	Alexander Atkins Design, Inc.
designer	Alexander Atkins
client	Wind River Systems
logo for	Technical support service.

97.1
design firm	Bruce Yelaska Design
designer	Bruce Yelaska
client	Messenger Greeting Cards
logo for	Whimsical line of greeting cards and accessories.

97.2
design firm	Fuse
designer	Matthew Stainer
client	Direct Fit
logo for	Overall corporate identity/brand, used in both print and digital mediums.

97.3
design firm	Moonlight Design
designer	Damon Seeley
art director	David Ryer
client	The Max Agency
logo for	A boutique ad agency.

98.1
design firm Earlywine Design
designer Terry Earlywine
client The Earlywine Family Crest
logo for Wine box labels.

98.2
design firm MJR Associates
designer Frank Ruiz
client Navmed
logo for Corporate identity used on stationery and
marketing materials.

98.3
design firm Kevin Akers Designs
designer Kevin Akers
client Kevin Akers Designs
logo for Design studio.

99.1
design firm Hennelly Design Office
designer Barbara Hennelly
client Hennelly Design Office
logo for Graphic designer business system
application.

99.2
design firm CKS Partners (Cupertino, CA)
designer Barbara Hennelly
art director Mike Bohrer
client Evoke

99.3
design firm Karen Mehoff & Co.
designer Karen Mehoff
client Pacific Power Systems, LLC
logo for Company identity for an electrical
systems integrator.

99.4
design firm Stewart Monderer Design, Inc.
designer Stewart Monderer
client Kallix Corporation
logo for Identity.

99.5
design firm Shimokochi/Reeves
designer Mamoru Shimokochi
client Zig Ziglar Network Trademark
logo for Corporate identity program.

99.6
design firm John Champ Design Associates
designer Randall Cohen
art director John Champ
client Certus International Incorporated
logo for Corporate identity.

98.1

98.2

98.3

99.1

99.2

99.3

kallix

99.4

ZIG ZIGLAR NETWORK

99.5

99.6

BURKE WILLIAMS

100.1

SonicSource™
CORPORATION

100.2

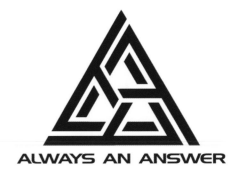

100.3

100.4

100.5

101.1

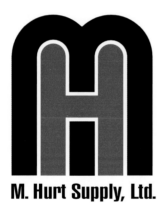

M. Hurt Supply, Ltd.

101.2

101.3

100.1	
design firm	Shimokochi/Reeves
designer	Mamoru Shimokochi
art director	Anne Reeves
client	Burke Williams
logo for	Branding identity & packaging system.

100.2	
design firm	Shields Design
designer	Laura Thornton
art director	Charles Shields
client	SonicSource
logo for	E-commerce.

100.3	
design firm	Engle + Murphy
designer	Mark Sojka
client	Corevent
logo for	Corporate ID for company that handles marketing and design for corporate-sponsored sports events.

100.4	
design firm	Moonlight Design
designer	David Ryer
client	Dental Advantage
logo for	Company providing consulting, financial and education services to dentists.

100.5	
design firm	Lawless Graphic Design
designer	John P. Lawless
client	Always An Answer
logo for	Financial consulting firm specializing in seeking solutions for foreclosure and bankruptcy prevention.

101.1	
design firm	Miriello Grafico, Inc.
designer	Chris Keeney, Dennis Garcia
client	Newport Communications

101.2	
design firm	Lawless Graphic Design
designer	John P. Lawless
client	M. Hurt Supply, Ltd.
logo for	Plumbing and electrical supply wholesaler.

101.3	
design firm	Vigon/Ellis
designer	Brian Jackson
art director	Larry Vigon
client	Adlink
logo for	Corporate identity.

102.1
design firm Stewart Monderer Design, Inc.
designer Stewart Monderer Design
client Dynisco, Inc.
logo for Identity.

102.2
design firm Earlywine Design
designer Terry Earlywine
client Stepping Stones
logo for Identity, stationery, signage and trucks for
 landscaping company.

102.3
design firm Zamboo
designers Becca Bootes, Chris Go
art director Dave Zambotti
client Demand Software
logo for Corporate identity.

103.1
design firm Lorenz
designer Arne Ratermanis
client Holocomm Systems, Inc.
logo for Company identity.

103.2
design firm Calori & Vanden-Eynden
designers Denise Funaro, Jordan Marcus
art director Chris Calori
client DC Heritage Tourism Coalition
logo for Marker of historical districts and trails in
 Washington, DC.

103.3
design firm Stewart Monderer Design, Inc.
designer Aime Lecusay
art director Stewart Monderer
client NBase/Xyplex
logo for Identity.

103.4
design firm Shimokochi/Reeves
designer Mamoru Shimokochi
art director Anne Reeves
client Beverly Sassoon International
logo for Branding identity & packaging system/
 specialty skin care.

103.5
design firm Vigon/Ellis
designer Brian Jackson
art director Larry Vigon
client Employers Group
logo for Corporate identity.

102.1

102.2

102.3

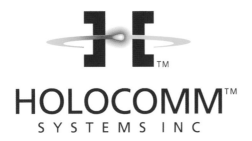

HOLOCOMM™
SYSTEMS INC

103.1

103.2

103.3

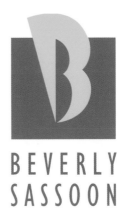

BEVERLY
SASSOON

103.4

employers
group *People & Productivity*

103.5

104.1

ABACUS

104.2

104.3

104.1
design firm McElveney & Palozzi Design Group, Inc.
art director Steve Palozzi
client Spring Street Society

104.2
design firm David Carter Graphic Design
designer Emily Cain
art director Lori Wilson
client Abacus Restaurant
logo for Restaurant in Dallas, Texas.

104.3
design firm Calori & Vanden-Eynden
designer Denise Funaro
art director Chris Calori
client Fulton Street Mall
logo for Business Improvement District.
Urban shopping area in Brooklyn, NY.

105.1
design firm Stephgrafx
designer Stephanie Payan
client Nuvonix Interactive
logo for Website company.

105.2
design firm Deluxe Brand
designer Tor Naerheim
client ARDEO
logo for Corporate identity for manufacturer of fire
retardant products.

105.3
design firm Vigon/Ellis
designer Marc Yeh
art director Larry Vigon
client Eteamz
logo for Corporate identity.

105.4
design firm Communications Design
designer Susan Leeson
art director Bill Sykes
client Advanced Technology Staffing
logo for Technology staffing agency for high-end
programmers.

105.5
design firm Vigon/Ellis
designers Marc Yeh, Brian Jackson
art director Larry Vigon
client Gravity Games
logo for Corporate identity.

105.1

105.2

105.3

105.4

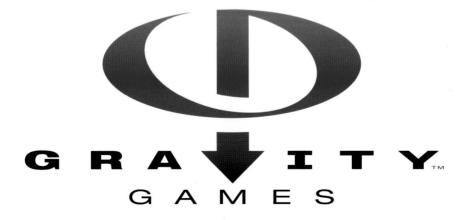

105.5

106.1
design firm Dutch Design
designer Rick Smits
client LRH Management
logo for Business cards.

106.2
design firm Bryan Friel Studio
designer Bryan Friel
client Manhattan Country Club
logo for Signage, corporate literature.

106.3
design firm Wolfback Design
designer Karin Scholz
client Synapse
logo for Corporate ID for Internet connectivity
consultants.

107.1
design firm Eve Vrla Design
designer Eve Vrla
client Trucenna Enterprises
logo for Corporate identity, stationery and signage
for general contractor.

107.2
design firm Earlywine Design
designer Terry Earlywine
client Massage at the Mansion
logo for Company identity, stationery, signage.

107.3
design firm Conover
designer David Conover
client Fraseworks
logo for Educational assessment firm.

107.4
design firm Seaman Design Group
designer Robin Seaman
client Typecraft, Inc.
logo for A printer with a technical edge over the
competition, They wanted to communicate
their leading position in the market.

107.5
design firm John Champ Design Associates
designer Randall Cohen
art director John Champ
client Quidel Corporation
logo for Sales incentive program.

106.1

MANHATTAN
C O U N T R Y C L U B

106.2

S Y N A P S E

106.3

TRUCENNA

107.1

107.2

107.3

107.4

ascend

107.5

108.1

108.2

108.3

108.4

108.5

108.6

PERSPECTA

09.1

EPLOYMENT

109.2

PALM
COMPUTING
PLATFORM

109.3

108.1
design firm Curry Design Associates
designer Steve Curry
client Muse X Editions
logo for Digital fine art printing company.

108.2
design firm Kevin Akers Designs
designer Kevin Akers
client Susan Sargent Designs
logo for Textile designer.

108.3
design firm Vigon/Ellis
designer Marc Yeh
art director Larry Vigon
client Matinee Entertainment
logo for Corporate identity.

108.4
design firm Vigon/Ellis
designer Marc Yeh
art director Larry Vigon
client Baldwin Productions
logo for Corporate identity.

108.5
design firm Vigon/Ellis
designer Marc Yeh
art director Larry Vigon
client Ereel
logo for Corporate identity.

108.6
design firm Curry Design Associates
designer Jason Scheideman
client Vanscoy
logo for Photographer.

109.1
design firm Elixir Design
designer Nathan Durrant
art director Jennifer Jerde
client Perspecta Inc.
logo for Company has created software enabling users to organize and navigate information in a simulated, multi-dimensional web space.

109.2
design firm Vigon/Ellis
designer Marc Yeh
art director Larry Vigon
client Eployment
logo for Corporate identity.

109.3
design firm Mortensen Design
designer Wendy Chon
art director Gordon Mortensen
client Hewlett-Packard (Palm computing)
logo for High-tech company.

110.1
design firm GSD Studio
designer Gary Solomon
client Mosaic
logo for Retail advertising and marketing Identity of all promotional items, website.

110.2
design firm Seaman Design Group
designer Robin Seaman
client Hope, Hispanas Organized for Political Equality
logo for Non-profit organization established to further the education and participation of Latina women in the political process.

110.3
design firm Mike Salisbury Communications
designer Logo Doctor
art director Mike Salisbury
illustrator Tim Clark
client Mike Salisbury
logo for Identity for a car dealership.

111.1
design firm Mortensen Design
designer PJ Nidecker
art director Gordon Mortensen
client Mirapoint, Inc.
logo for High-tech company.

111.2
design firm Stoyan Design
designer Michael Stinson
client Bell Photography

111.3
design firm Vigon/Ellis
designer Brian Jackson
art director Larry Vigon
client Air Creative Group
logo for Corporate identity.

111.4
design firm Sabingrafik, Inc.
designer Tracy Sabin
illustrator Tracy Sabin
client Tom Stacey
logo for A copywriter.

110.1

110.2

110.3

M I R A P O I N T

111.1

111.2

111.3

AIR CREATIVE GROUP

111.4

112.1

112.2

112.3

cmc

112.4

112.1
design firm Zamboo
designer Dave Zambotti
art director Becca Bootes
client Creative Management Coordinators
logo for Corporate identity.

112.2
design firm Lamfers & Associates
designer Missy Nery
art director Debra Lamfers
client News Printing Company, Inc.
logo for Company identity and applications for a
 printer specializing in newspaper production.

112.3
design firm John Champ Design Associates
designer Randall Cohen
art director John Champ
client Hospital Associates
logo for Corporate identity.

112.4
design firm John Champ Design Associates
designers Randall Cohen, Diana Kauzlarich
art director John Champ
client Corporate Meeting Concepts
logo for Corporate identity.

113.1
design firm John Champ Design Associates
designer Randall Cohen
client Hayer/Magnus Architects
logo for Corporate identity.

113.2
design firm MJR Associates
designer Aimee McKirdy
art director Frank Ruiz
client Facility Designs
logo for Corporate identity used on stationery,
 signage and marketing materials.

113.3
design firm ComCorp, Inc.
designer ComCorp Staff
art director Debbie Werner
client China Television Ventures
logo for Corporate material.

113.4
design firm Seaman Design Group
designer Robin Seaman
client Container.com
logo for A national company involved in the rental and
 sales of portable steel storage containers.

113.5
design firm Stephgrafx
designer Stephanie Payan
client Cheyenne Pools
logo for Local swimming pool contract builder.

113.1

FACILITY
DESIGNS

113.2

CHINA

TELEVISION

VENTURES

113.3

113.4

CHEYENNE POOLS
CRAFTSMANSHIP

113.5

JAHN INVESTMENT
ADVISORS

114.1

Good Vibes!
Promotions

114.2

▶ THERE'S MORE IN IT™ ◀

114.3

LAGUNA ART MUSEUM

114.4

115.1

ORANGE COUNTY

museum of art

115.2

BMJ

Baker, Manock & Jensen

ATTORNEYS AT LAW

115.3

114.1
design firm Benita Oberg Design
designer Benita Oberg
client Jahn Investment Advisors
logo for Stationery, business cards, letterhead, envelopes, collateral (newsletters).

114.2
design firm Deluxe Brand
designer Tor Naerheim
client Good Vibes
logo for Los Angeles club promotion.

114.3
design firm Miriello Grafico, Inc.
designer Chris Keeney
art director Ron Miriello
logo for Hot Z.

114.4
design firm Mike Salisbury Communications
designer Mike Salisbury
illustrator Brian Sisson
client Laguna Art Museum

115.1
design firm Sandy Gin Design
designer Sandy Gin
client Sandy Gin Design
logo for A design studio.

115.2
design firm Mike Salisbury Communications
designer Mike Salisbury
illustrator Bob Maile
client Orange County Museum of Art

115.3
design firm Shields Design
designer Charles Shields
client Baker, Manock & Jensen
logo for Law firm.

Broudy Printing Inc.
SEE THE POWER OF FINE PRINTING

116.1

WRIGHT WILLIAMS & KELLY

116.2

LIST ENGINEERING COMPANY

Mechanical Consultants

116.3

116.4

116.5

116

Industrial Technology Management, Inc

117.1

Junglee

117.2

ACCU-TIME, INC.

117.3

116.1
design firm Lamfers & Associates
designer Missy Nery
art director Debra Lamfers
client Broudy Printing, Inc.
logo for Company identity and applications.
 Broudy Printing is high-end web and
 sheet-fed printer.

116.2
design firm The Wecker Group
designer Robert Wecker
client Wright, Williams & Kelly
logo for Signage, packaging, stationery,
 collateral, forms.

116.3
design firm The Wecker Group
designer Robert Wecker
client List Engineering Company
logo for Signage, stationery, forms.

116.4
design firm Lamfers & Associates
designer Missy Nery
art director Debra Lamfers
client Lamfers & Associates
logo for Company identity—applied to all print and
 electronic media for design firm.

116.5
design firm Paul Rogers
designer Paul Rogers
client Society of Illustrators Los Angeles
logo for Organization of illustrators.

117.1
design firm Innovative Design and Advertising
designers Susan Nickey-Newton,
 Kim Crossett-Neumann
client Industrial Technology Management, Inc.
logo for Letterhead, business cards, envelopes, etc.

117.2
design firm Mortensen Design
designer Diana L. Kauzlarich
art director Gordon Mortensen
client Junglee Corporation
logo for High-tech company.

117.3
design firm Lawless Graphic Design
designer John P. Lawless
client Accu-Times, Inc.
logo for Time recorders and devices suppliers.

118.1

118.1
design firm McElveney & Palozzi Design Group, Inc.
designer Jon Westfall
art directors William McElveney, Steve Polozzi
client McElveney & Palozzi Design Group, Inc.
logo for Letterhead, business cards, envelopes, sell sheets.

118.2
design firm Warren Group
designers Katherine Staats, Laura Mische
art director Linda Warren
client Creative Wonder
logo for Stationery.

118.3
design firm GDS Studio
designer Gary Solomon
client Burke Williams
logo for Signage, robes, uniforms, retail gift items, spa floor, all promotional materials.

119.1
design firm Curry Design Associates
designer Jason Scheideman
client WTA
logo for Typographers association.

119.2
design firm Juddesign
designers Eric Watanabe, Amy Williams
art director Patti Judd
client Dakota Group
logo for Full service marketing/communications organization.

119.3
design firm Miriello Grafico, Inc.
designer Dennis Garcia
client Technically Correct

119.4
design firm Eve Vrla Design
designer Eve Vrla
client The Eastridge Companies
logo for Stationery, brochures and signage for real estate services.

118.2

118.3

119.1

119.2

Technically

Correct

119.3

THE EASTRIDGE COMPANIES

119.4

120.1

ValueNET®

120.2

GROWTH
N E T W O R K S

120.3

120.1
design firm GDS Studio
designer Gary Solomon
client Net Advantage
logo for Interactive marketing solutions identity and promotion, website.

120.2
design firm Curry Design Associates
designer Pyong Mun
client Valuenet
logo for Online service software.

120.3
design firm Mortensen Design
designer Wendy Chon
art director Gordon Mortensen
client Growth Networks
logo for High-tech company.

121.1
design firm Engle + Murphy
designer Emily Moe
client Container.com
logo for Corporate ID for company that sells and leases oversized metal storage containers.

121.2
design firm Engle + Murphy
designer Robin Seaman
client Humana Worker's Compensation Services
logo for A division of Humana that assists in the process of returning injured workers to productive roles within the workplace.

121.3
design firm Engle + Murphy
designer Robin Seaman
client ebiocare.com
logo for E-commerce company that provides products and services to individuals with rare chronic disorders.

121.4
design firm Wolfback Design
designer Karin Scholz
client Waveband
logo for Corporate ID for a microwave optics corporation.

121.5
design firm McElveney & Palozzi Design Group, Inc.
designer Paul Reisinger, Jr.
art directors Steve Palozzi, Matt Nowicki
client LPA Software
logo for Brochure, tradeshow booth, website.

121.6
design firm Stone Yamashita
designer Jennifer Olsen
art directors Keith Yamashita, Robert Stone
client Hewlett-Packard
logo for E-speak, the technology embedded in devices to complete E-services.

121.1

121.2

121.3

121.4

121.5

e"speak.™

121.6

122.1

122.2

122.3

122.4

122.1
design firm Akagi Remington
designer Christopher Simmons
art director Doug Akagi
client OfficeClick.com
logo for Web portal for administrative assistants.

122.2
design firm Stewart Monderer Design, Inc.
designer Stewart Monderer
client MarketSoft Corporation
logo for Identity.

122.3
design firm Fuse
designer Mike Esparanza
client PairGain
logo for Corporate identity/brand, used in both print
 and digital mediums.

122.4
design firm Morreal Graphic Design
designer Mary Lou Morreal
client Cyberwerks Interactive
logo for Stationery, packaging, collateral.

123.1
design firm Shields Design
designer Charles Shields
art director Stephanie Wong
client Protosource Network
logo for Internet service provider.

123.2
design firm Shields Design
designers Thomas Kimmelman, Charles Shields
art director Stephanie Wong
client Digital Production Group
logo for Multimedia facilities.

123.3
design firm Zamboo
designer David Zambotti
client Direct Digital Communications
logo for Corporate identity.

123.4
design firm VWA Group
designer Rhonda Warren
client Connect.com
logo for High speed telecommunications access.

123.1

123.2

123.3

123.4

124.1

design firm	Fitch
designer	Cris Logan
art director	Valloula Vasiliou
client	Kärna LLC
logo for	Corporate identity and product endorsement, stationery and web use for an innovative precision technology company.

124.2

design firm	The Wecker Group
designer	Robert Wecker
client	Universal Internet
logo for	Signage, stationery, form, collateral.

124.3

design firm	Miriello Grafico, Inc.
designer	Chris Keeney
client	Microlink

125.1

design firm	McElveney & Palozzi Design Group, Inc.
art directors	William McElveney, Lisa Williamson
client	PC Assistance, Inc.
logo for	Letterhead, business cards, envelopes, brochure, containment folder.

125.2

design firm	Morreal Graphic Design
designer	Mary Lou Morreal
client	SOMC Group Inc.
logo for	Stationery, signage, collateral materials for Software of the Month Club.

125.3

design firm	Stewart Monderer Design, Inc.
designer	Aime Lecusay
art director	Stewart Monderer
client	eCredit.com, Inc.
logo for	Identity.

124.2

124.3

125.1

125.2

125.3

novo interactive

novo interactive

126.1

novo interactive

novo interactive

HOME

NEWS

SEARCH

EMAIL

LINKS

BACK

NEXT

FAQ

126.2

home

search

mail

shop

126.3

126.1
design firm Oh Boy, A Design Company
designer Alice Chang
art director David Salanitro
client Novo Interactive
logo for Business papers, website.

126.2
design firm Morreal Graphic Design
designer Mary Lou Morreal
client Bright Ideas
logo for Magazine & website.

126.3
design firm Morreal Graphic Design
designer Mary Lou Morreal
client Bright Ideas
logo for Magazine.

127.1
design firm Fitch
designers Cris Logan, Kian Kuan
art director Vassoula Vasiliou
client Be Incorporated
logo for Company and software identity
 system, packaging, marketing material,
 web. PC operating system icon.

127.2
design firm Alexander Atkins Design, Inc.
designer Alexander Atkins
client Capri Systems
logo for Systems integration company that develops
 advanced call centers.

127.3
design firm Stewart Monderer Design, Inc.
designer Stewart Monderer
client Electronic Book Technologies, Inc.
logo for Identity.

127.4
design firm LF Banks + Associates
designer John German
art director Lori F. Banks
client @Risk, Inc.
logo for Corporate identity for data mining company.

127.1

127.2

127.3

127.4

128.1

128.2

128.3

128.4

128.1		
design firm	LF Banks + Associates	
designer	John German	
art director	Lori F. Banks	
client	BileniaTech, LP	
logo for	Corporate identity for company that handles technology needs for businesses.	
128.2		
design firm	Fuse	
designer	Russell Pierce	
client	Fuse	
logo for	Identity/brand for digital and print mediums.	
128.3		
design firm	Foreshock	
designer	Gary Zdeneck	
client	Foreshock	
logo for	Company identity for print and web.	
128.4		
design firm	Lawless Graphic Design	
designer	John P. Lawless	
client	Lasertrek	
logo for	Laser tag business.	
129.1		
design firm	Mike Salisbury Communications	
designer	Tor Naerheim	
art director	Mike Salisbury	
illustrator	Derek Harven	
client	Bungie	
logo for	Halo computer game.	
129.2		
design firm	Earlywine Design	
designer	Terry Earlywine	
client	Warman Commercial Building Engineer	
logo for	Company identity, stationery, signage.	
129.3		
design firm	The Illusion Factory	
designers	Sahak Ekshian, Karen Ann Toal	
art director	Brian Weiner	
illustrator	Sahak Ekshian	
client	The Illusion Factory	
logo for	All corporate ID, brochure, bus card, letter-head, website, motion logo for video and film.	
129.4		
design firm	ComCorp, Inc.	
designer	ComCorp Staff	
art director	Abby Mines	
client	MLP Network, Inc.	
logo for	Corporate material.	
129.5		
design firm	Earlywine Design	
designer	Terry Earlywine	
client	International Sparc Technology Seminars	
logo for	Tradeshow collateral, signage, stationery.	

WARMAN

129.1

129.2

THE ILLUSION FACTORY

129.3

network, inc.

129.4

129.5

★
129

SMARTsuite

130.1

CORE

S O F T W A R E

130.2

130.3

Crash Tech

130.4

130.5

MSP #618

130.1

design firm	Talbot Design Group
designer	Chris Kosman
art director	GayLyn Talbot
client	Traveler's Telecom
logo for	New product—"Smart Suite." (product sheets, stationery, advertising, trade show collateral), website.

130.2

design firm	Curry Design Associates
designer	Jason Scheideman
art director	Steve Curry
client	Core Software
logo for	Global imaging software.

130.3

design firm	Tharp Did It
designers	Rick Tharp, Debra Naeve
client	NuTryx
logo for	Internet training for senior citizens.

130.4

design firm	Klass Design
designer	Logo Doctor
art director	Tim Clark
illustrator	Teri Klass
client	Crash Tech
logo for	Identity for Mac repair technician.

130.5

design firm	Michael Osborne Design
designer	Andy Cambouris
art director	Michael Osborne
client	Enginewear, Inc.
logo for	Women's sportswear.

131.1

design firm	Boardwalk
designer	Harriet Breitborde
client	Channel Surfing
logo for	Signage, on-air promotion marketing.

131.2

design firm	Tharp Did It
designers	Rick Tharp, Phillip Kim
art director	Stephanie Paulson/The Stephenz Group
client	Xerox
logo for	Identifying a video conferencing technology.

131.3

design firm	Curry Design Associates
designer	Pyong Mun
art director	Steve Curry
client	Interactive Video Technologies
logo for	Video broadcast on the Internet.

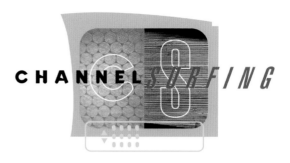

131.1

131.2

131.3

132.1
design firm B3 Design
designer Barbara B. Breashears
client Burton Valley Elementary P.T.A.
logo for Swingin' Into 2000 silent/live
 auction/fundraising.

132.2
design firm Seaman Design Group
designer Robin Seaman
client Voice Center for Arts and Medicine
logo for A medical facility that specializes in the
 treatment of singers and actors.

132.3
design firm Fuse
designer Kristi Kamei
client Yamaha Drums
logo for Overall corporate identity/brand used in
 both print and digital mediums.

133.1
design firm Innovative Design and Advertising
designers Susan Nickey-Newton,
 Kim Crossett-Neumannn
client ABC—5th Floor Production Music Library
logo for Corporate identity, business cards, sta-
 tionery, CD labels, etc.

133.2
design firm Klass Design
designer Logo Doctor
art directors Tim Clark, Teri Klass
illustrator Tim Clark
client The Toledo Band
logo for Proposed identity and promotion for club
 band.

133.3
design firm Vigon/Ellis
designer Brian Jackson
art director Larry Vigon
client Welk Resort Center
logo for Corporate identity.

133.4
design firm Kevin Akers Designs
designer Kevin Akers
client San Francisco Symphony
logo for Chorus 25th Anniversary.

132.1

132.2

132.3

FIFTH 5 FLOOR
PRODUCTION MUSIC LIBRARY

133.1

133.2

WELK RESORT CENTER

133.3

133.4

134.1

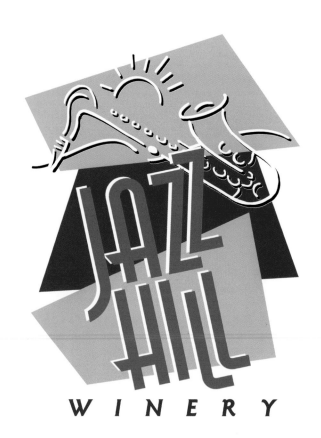

WINERY

134.2

KARAOKE KIM

135.1

134.1
design firm Sabingrafik, Inc.
designer Dann Wilson
illustrator Tracy Sabin
client Jake's Jam
logo for A musical performance.

134.2
design firm The Wecker Group
designer Robert Wecker
client Cask One Vineyards
logo for Labels, packaging.

135.1
design firm Klass Design
designer Logo Doctor
art director Teri Klass
illustrator Tim Clark
client Karaoke Kim
logo for Identity for a bar.

135.2
design firm Seineger Design
designer Logo Doctor
art director Tony Seineger
illustrator Tim Clark
client Dreamgirls Production
logo for Poster.

135.3
design firm Vigon/Ellis
designer Marc Yeh
art director Larry Vigon
client Fleetwood Music
logo for Corporate identity.

DreamGirls

135.2

FLEETWOOD
MUSIC

135.3

136.1

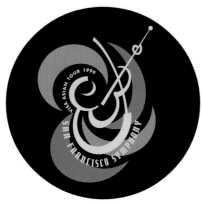

136.2

136.1
design firm Calori & Vanden-Eynden
designers Chris Calori, David Vanden-Eynden
client Gig Wear Store
logo for Retailer of rock and roll memorabilia.

136.2
design firm Kevin Akers Designs
designer Kevin Akers
client San Francisco Symphony
logo for Asian tour 1999.

136.3
design firm Kevin Akers Designs
designer Kevin Akers
client San Francisco Symphony
logo for T-shirts promoting SFS-Greatful
 Dead members concert.

137.1
design firm Kevin Akers Designs
designer Kevin Akers
client San Francisco Symphony
logo for Holiday program icon.

137.2
design firm Kevin Akers Designs
designer Kevin Akers
client San Francisco Symphony
logo for European concert tour.

136.3

137.1

137.2

138.1
design firm David Carter Graphic Design
designer Tien Pham
art director Lori Wilson
client Atlantis Resort and Casino
logo for Atlas Bar & Grill/Nassau, The Bahamas.

138.2
design firm Crouch & Naegli
art directors Jim Crouch, Jim Naegli
illustrator Tracy Sabin
client University of California at San Diego
logo for Tritons sports team.

138.3
design firm Focus Design
designer Brian Jacobson
client Appearance Salon
logo for Retail identity.

139.1
design firm Robert Miles Runyon
designer Logo Doctor
art director Tom Devine
illustrator Tim Clark
client Caesar's Palace
logo for Merchandising for Las Vegas hotel.

139.2
design firm David Carter Graphic Design
designer Tien Pham
art director Lori Wilson
client Disney Cruise Line
logo for Quarter Masters.

139.3
design firm VWA Group
designer Brian Blankenship
art director Rhonda Warren
client Quicksilver
logo for Identity, letterhead, automobile
 application, brochure.

139.4
design firm Michael Osborne Design
designer Andy Cambouris
art director Michael Osborne
illustrator Carolyn Vibbert
client Money Heaven
logo for Venture capital.

138.1

138.2

138.3

CAESARS PALACE

139.1

139.2

QUICKSILVER

MOBILE CAR WASH AND DETAIL

139.3

money heaven

139.4

140.1
design firm Kevin Akers Designs
designer Kevin Akers
client Tulips Express
logo for Air shipping/tulip bulbs company.

140.2
design firm Allen Orr
designer Allen Orr
client Valley Mailing Service

140.3
design firm Lorenz
designer Arne Ratermanis
client Gowan Seed Company
logo for Company identity.

141.1
design firm Stephgrafx
designer Stephanie Payan
client Palmer Group/Kathryn Fulhorst
logo for Landscape architect.

141.2
design firm Kevin Akers Designs
designer Kevin Akers
client Country Growers
logo for Nursery/hot house.

141.3
design firm The Wecker Group
designer Robert Wecker
client Canterbury Woods
logo for All applications.

141.4
design firm ComCorp, Inc.
designer Dave Lawrence
art director Debbie Werner
client FMC Corporation
logo for Corporate material.

140.1

140.2

GOWAN SEED
COMPANY

140.3

141.1

141.2

CANTERBURY WOODS
A RETIREMENT RESIDENCE

141.3

141.4

MONTEREY PENINSULA CHAMBER OF COMMERCE

142.1

142.2

142.3

LANDSCAPE INNOVATIONS

142.4

142.5

The Forest Foundation

143.1

NEW LEAF
PAPER

143.2

ALCALA

143.3

144.1

144.2

144.3

144.4

144.1
design firm The Wecker Group
designer Matt Gnibus
art director Rober Wecker
client Monterey Bay Kayaks
logo for T-shirts.

144.2
design firm Moonlight Design
designer David Ryer
client The Bone Marrow Foundation
logo for Non-profit organization offering support
 services to patients requiring bone marrow
 transplants, and their families.

144.3
design firm McElveney & Palozzi Design Group, Inc.
designer Jan Marie Gallagher
art directors William McElveney, Lisa Parenti
client LeRoy Village Green
logo for Letterhead, business cards, envelopes, pock-
 et folder, brochure, tradeshow booth.

144.4
design firm Nita Ybarra Design
designer Nita Ybarra
client AnyIsland.com
logo for E-commerce, Internet, business.

MSP #545
145.1
design firm Seaman Design Group
designer Robin Seaman
client City of Orange Redevelopment Agency
logo for Agency that visually demonstrates move-
 ment, change and rebirth.

145.2
design firm MJR Associates
designer Frank Ruiz
client Cranberry Marketing Committee
logo for Corporate identity used on stationery and
 marketing materials.

145.3
design firm John Sposato Design & Illustration
designer John Sposato
art director Loretta Leiva
illustrator John Sposato
client John Wiley & Sons
logo for A line of financial advice products.

145.4
design firm Elixir Design
designer Nathan Durrant
art director Jennifer Jerde
client Grandiflorum Perfumes
logo for Perfumer specializing in custom-blended,
 all-natural fragrances.

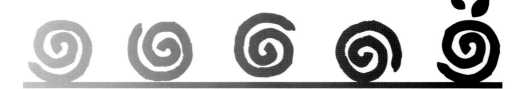

145.1

145.2

WILEY PERSONAL FINANCE SOLUTIONS

145.3

GRANDIFLORUM

PERFUMES

145.4

146.1

146.2

146.3

146.4

146.1
design firm Dutch Design
designer Rick Smits
client St. Margaret Mercy Hospital
logo for Proposed logo for fund-raising
 marathon T-shirt.

146.2
design firm Susan Meshberg Graphic Design
designer Susan Meshberg
illustrator Richard Mechanik
client 67 Wine & Spirits
logo for Retail liquor store.

146.3
design firm Dean Mitchell Design
designer Dean Mitchell
illustrators Steve Schadt, Alberto Zavallos
client PAR Broadcasting
logo for New Rock-format station.

146.4
design firm Wolfback Design
designer Karin Scholz
client Grace Hopper
logo for Conference celebrating women in computer
 science.

147.1
design firm David Carter Graphic Design
designer Sharon LeJeune
art director Lori Wilson
client Atlantis Resort and Casino
logo for 5 Twins/Nassau, The Bahamas.

147.2
design firm Michael Osborne Design
designer Michelle Regenbogen
art director Michael Osborne
client San Francisco Museum of Modern Art
logo for Merchandise 2000.

147.3
design firm The Wecker Group
designer Robert Wecker
client Meeting Professionals International
logo for Northern California Chapter/stationery,
 collateral.

147.4
design firm ComCorp, Inc.
designer Ron Alikpala
art director Abby Mines
client Chicago Manufacturing Center
logo for 1999 Year of the Small Manufacturer
 Conference (web, print, video).

FIVE TWINS

147.1

2000

MICHAEL OSBORNE DESIGN ©SIMONA 1999

SAN FRANCISCO MUSEUM OF MODERN ART

147.2

MILLENNIUM
MaNiA
2000

147.3

MANUFACTURING COUNTS

CHICAGO | 1999 YEAR OF THE SMALL MANUFACTURER

147.4

148.1
design firm Zamboo
designer Becca Bootes
art director Dave Zambotti
client Premiere Dental Group
logo for Corporate identity.

148.2
design firm Kevin Akers Designs
designer Kevin Akers
client Inland Heart Center
logo for Cardiac care hospital.

148.3
design firm Zamboo
designer Becca Bootes
art director Dave Zambotti
client Tops Restaurant
logo for Corporate identity.

149.1
design firm Moonlight Design
designer David Ryer
client Futuredontics
logo for Portal website serving as search engine and
 directory for dentists and dental services
 (consumer and business-to-business).

149.2
design firm Allen Orr
designer Allen Orr
client SCS Dental Supply

149.3
design firm Sandy Gin Design
designer Sandy Gin
client Origin Medsystems
logo for Cardiovascular products at a medical device
 company.

149.4
design firm Stephgrafx
designer Stephanie Payan
client Southwest Medical Transcription
logo for Medical records transcription.

149.5
design firm BobCo Design Inc.
designer Robert S. Nenninger
client BobCo Design Inc.
logo for Corporate identity for a graphic design firm.

148.1

148.2

148.3

THE INTERNET DENTAL RESOURCE

149.1

149.2

149.3

149.4

BobCo Design Inc

149.5

VerSecure

150.1

150.2

MAGIC HOUR
P I C T U R E S

150.3

VISA MAGIC
MOMENTS

150.4

R O S I E

150.5

151.1

151.2

151.3

INSITES

INSITES

INSITES

INSITES

152.1

152.2

153.1

153.2

BACKROAD
ANTIQUES

153.3

152.1
design firm Stone Yamashita
designer Jennifer Olsen
client Insites
logo for Company that organizes all aspects of
 events, conferences, speech writing, etc.

MSP #279
152.2
design firm Kevin Akers Designs
designer Kevin Akers
client Chevron
logo for Maintenance manager for truck maintenance
 program.

153.1
design firm The Wecker Group
designer Robert Wecker
client Monterey Peninsula School District
logo for Stationery, forms.

153.2
design firm Kevin Akers Designs
designer Kevin Akers
client Judee & Kevin's Wedding
logo for Wedding invitation and related items.

153.3
design firm Jeffry Hipp
designer Jeffry Hipp
client Backroad Antiques
logo for Identity for an antiques store.

154.1

Pacific Park

154.2

154.3

154.1
design firm	GDS Studio
designer	Gary Solomon
client	GSD Studio
logo for	Identity, stationery system and all promotion including website.

154.2
design firm	Boardwalk
designer	Harriet Breitborde
client	Pacific Park
logo for	Signage, marketing and advertising product applications for the theme park.

154.3
design firm	Moonlight Design
designer	David Ryer
client	Pension Resources
logo for	Company providing retirement fund management.

154.4
design firm	Sabingrafik, Inc.
designer	Tracy Sabin
art director	Marilee Bankert
illustrator	Tracy Sabin
client	Oliver McMillin
logo for	Retail/entertainment center.

155.1
design firm	Kevin Akers Designs
designer	Kevin Akers
client	San Francisco Symphony
logo for	Black & White Ball—charity event.

O C E A N P L A C E

154.4

Black & White Ball®

155.1

THE MANSION
at MGM Grand

156.1

STAYWELL

156.2

SILVER PICTURES

156.3

1500 K STREET
THE SOUTHERN RAILWAY BUILDING

156.4

156.1
design firm — David Carter Graphic Design
designer — Ashley Barron
art director — Lori Wilson
client — The Mansion
logo for — MGM Grand/Las Vegas, Nevada.

156.2
design firm — Kevin Akers Designs
designer — Kevin Akers
client — StayWell
logo for — Health publications company.

156.3
design firm — Heart Times Coffee Cup Equals Lighting
designer — Paul Rogers
art director — Bobby Woods
client — Silver Pictures
logo for — Motion picture company.

156.4
design firm — ComCorp, Inc.
designer — ComCorp Staff
art director — Abby Mines
client — Jones Lang LaSalle
logo for — Property marketing material.

157.1
design firm — MJR Associates
designer — Frank Ruiz
client — Habanos Cigars
logo for — Corporate identity used on stationery and marketing materials.

157.2
design firm — Miriello Grafico, Inc.
designer — Chris Keeney
client — Spirit

157.3
design firm — McElveney & Palozzi Design Group, Inc.
art director — William McElveney, Lisa Parenti
client — Abbott's Frozen Custard
logo for — Posters, FSI's, coupons.

157.4
design firm — MJR Associates
designer — Frank Ruiz
client — Hugs & Kisses
logo for — Corporate identity used on stationery, signage and marketing materials.

the fine cigar people

157.1

A Mind/Body Experience

a r u b a

157.2

157.3

COUNTRY GIFTS AND HOME DECOR

157.4

158.1

158.2

FIRESTONE WALKER BREWING COMPANY

158.3

JEFFERSON AT
Creekside

158.4

159.1

THE GREATEST NAME IN COLOR

159.2

159.3

MIRABELLA

159.4

158.1
design firm VWA Group
designer Brian Blankenship
art director Rhonda Warren
client Lincoln Property Company
logo for Identity, letterhead, brochure for
Regents Court.

158.2
design firm Moonlight Design
designer David Ryer
client International Interior Design Association
logo for Juried annual award given by interior
designers to creators/manufacturers of new
furniture, finishes and accessories.

158.3
design firm Pierre Rademaker Design
designers Pierre Rademaker, Marci Russo
client Firestone Walker Brewery
logo for Signage, print items, packaging.

158.4
design firm VWA Group
designer Brian Blankenship
art director Rhonda Warren
client Jefferson Property Inc.
logo for Identity, letterhead, brochure for Jefferson
at Creekside.

MSP #608
159.1
design firm Susan Meshberg Graphic Design
designer Susan Meshberg
client Bel Canto Fancy Foods Ltd.
logo for Packaging product line of specialty food
importer.

159.2
design firm Tsuchiya Sloneker Communications, Inc.
designer Matthew Schneider
art directors Mark Sloneker, Julie Tsuchiya
illustrators Matthew Schneider, Colin O'Neill
client Technicolor
logo for Corporate identity package, film, packaging.

159.3
design firm Bryan Friel Studio
designer Bryan Friel
client Touché
logo for Signage, garment tags, corporate literature.

159.4
design firm VWA Group
designer Rhonda Warren
illustrator Lem Lo
client JPI
logo for Luxury apartment homes.

160.1

160.2

160.3

The Smittcamp Family
HONORS COLLEGE
California State University, Fresno

160.4

160.1
design firm Shields Design
designer Charles Shields
illustrator Doug Hansen
client The Ken Roberts Company
logo for Investment program.

160.2
design firm Mortensen Design
designer Wendy Chon
art director Gordon Mortensen
client Bank of Petaluma
logo for The bank.

160.3
design firm The Stricklin Companies
designer Julie Ann Stricklin
art director Ilsa House
client Environmental Perspectives
logo for Identity package.

160.4
design firm Shields Design
designer Charles Shields
art director Stephanie Wong
illustrator Doug Hansen
client Smittcamp Family Honors College
logo for Honors College.

161.1
design firm Marv Cooper Design
art director Doug Hardenburg
illustrator Tracy Sabin
logo for A restaurant featuring a wood-fired grill.

161.2
design firm Idea Place
designer Paul Rogers
art director Jon Sparmann
illustrator Paul Rogers
client Populuxe Productions
logo for Film production company.

161.3
design firm Michael Osborne Design
designer Michelle Regenbogen
art director Michael Osborne
illustrator Michelle Regenbogen
client USS Hornet Museum
logo for Museum store merchandise.

161.4
design firm Lorenz
designer Arne Ratermanis
client Janda & Garrington, LLC
logo for Company identity.

161.1

161.2

161.3

JANDA & GARRINGTON
L L C

161.4

162.1

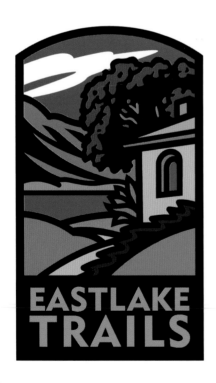

162.2

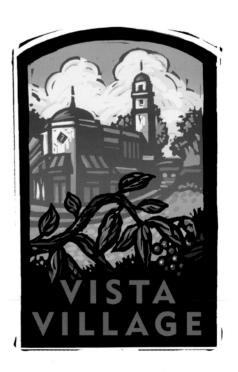

162.3

162

162.1
design firm Tyler Blik Design
art directors Ron Fleming, Tyler Blik
illustrator Tracy Sabin
client Otay Ranch
logo for Housing development.

162.2
design firm Matthews/Mark
designers Jon Meyers, Tracy Sabin
illustrator Tracy Sabin
client Eastlake Trails
logo for A housing development.

162.3
design firm Sabingrafik, Inc.
designer Tracy Sabin
art director Mirilee Bankert
illustrator Tracy Sabin
client Oliver McMillin
logo for Shopping center.

163.1
design firm The Wecker Group
designer Robert Wecker
illustrator Harry Briggs
client Saucy Ree's Gourmet Foods
logo for Packaging, stationery.

163.2
design firm Shields Design
designer Charles Shields
art director Stephanie Wong
illustrator Doug Hansen
client Gold Coast Pistachios
logo for Pistachio grower.

163.3
design firm McElveney & Palozzi Design Group, Inc.
art directors Steve Palozzi, Matt Nowicki
client Genessee Brewing Company
logo for Packaging—High Falls.

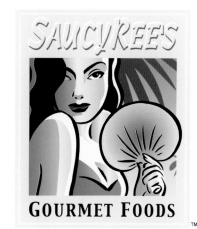

163.1

163.2

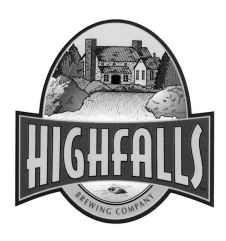

163.3

164.1
design firm The Flowers Group
designer Cory Shehan
illustrator Tracy Sabin
client The Ridge
logo for Rustic golf resort.

164.2
design firm Conover
designers Carlos Avina, Amy Williams
art director David Conover
illustrator Dan Thoner
client Eldorado Stone
logo for Manufacturer of stone veneers.

164.3
design firm Pierre Rademaker Design
art director Pierre Rademaker
client Solvang Visitors & Convention Bureau
logo for Print items, souvenirs, outdoor boards,
 collateral.

165.1
design firm Pierre Rademaker Design
designers Pierre Rademaker, Debbie Shibata
client San Luis Obispo Chamber of Commerce
logo for Promotional gift items, souvenirs, apparel.

165.2
design firm Pierre Rademaker Design
designers Pierre Rademaker, Jeff Austin
client Paso Robles Inn
logo for Print items, advertising, signage, outdoor
 boards.

165.3
design firm Pierre Rademaker Design
designers Pierre Rademaker, Jeff Austin
client Ocean View Flowers
logo for Print items, product tags, packaging,
 advertising, vehicles, signage.

165.4
design firm Shields Design
designer Charles Shields
illustrator Doug Hansen
client Great Pacific Trading Company
logo for Investments company.

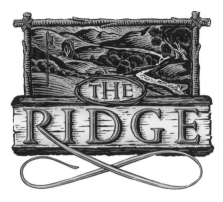

164.1

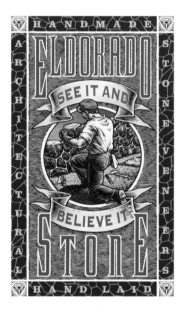

164.2

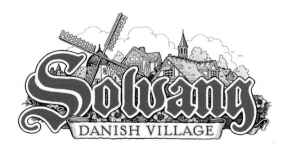

164.3

165.1

165.2

165.3

165.4

CARLSBAD BY THE SEA
Retirement Community

166.1

166.2

166.3

166.1
design firm	Juddesign
art director	Patti Judd
client	Carlsbad By The Sea
logo for	Retirement community.

166.2
design firm	The Wecker Group
designer	Robert Wecker
illustrator	Mark Savee
client	Cannery Row Inn
logo for	Signage, stationery.

166.3
design firm	The Wecker Group
designer	Robert Wecker
client	Cypress Tree Inn
logo for	Signage, stationery.

167.1
design firm	Vitro/Robertson
art director	Jeff Payne
illustrator	Tracy Sabin
client	Rubio's Baja Grill
logo for	Matchbook cover for a TV spot.

167.2
design firm	GDS Studio
designer	Gary Solomon
art director	Jerry Cowart
illustrator	Gary Solomon
client	Candle Corporation
logo for	Annual sweepstakes trip vacation, this time to Aruba.

167.3
design firm	Sabingrafik, Inc.
designer	Tracy Sabin
art director	Marilee Bankert
illustrator	Tracy Sabin
client	Oliver McMillin
logo for	Shopping center/entertainment complex.

167.1

167.2

167.3

168.1
design firm The Alfstad Blank Group
designer Logo Doctor
art director Chuck Moore
illustrators Tim Clark, Teri Klass
client MantaRay
logo for Software packaging.

168.2
design firm Tharp Did It
designers Rick Tharp, Nicole Coleman
client Steamer's The Grillhouse
logo for Restaurant signage, menus, apparel.

168.1

168.3
design firm Klass Design
designer Logo Doctor
art director Teri Klass
illustrators Tim Clark, Teri Klass
client Splash Entertainment
logo for Identity for a production company.

169.1
design firm David Carter Graphic Design
designer Tien Pham
art director Lori Wilson
client Atlantis Resort and Casino
logo for Fathoms/Nassau, The Bahamas.

169.2
design firm BobCo Design Inc.
designer Robert S. Nenninger
client Fishking, Inc.
logo for Corporate identity for a Japanese-owned
 fish processing company in Los Angeles.

168.2

169.3
design firm The Wecker Group
designers Robert Wecker, Matt Gnibus
client Aquafuture, Inc.
logo for All applications.

169.4
design firm The Wecker Group
designers Robert Wecker, Matt Gnibus
client Aquafuture, Inc.
logo for All applications.

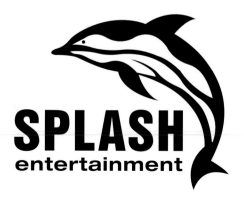

168.3

F A T H O M S

169.1

Fishking

169.2

AQUAFUTURE

169.3

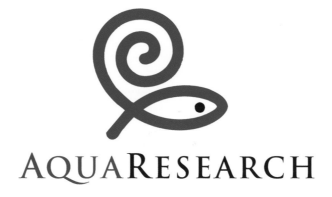

AQUARESEARCH

169.4

Isla Nena

170.1

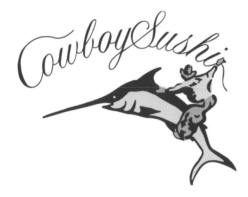

170.2

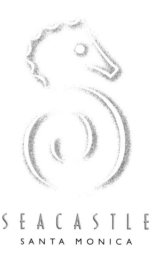

SEACASTLE
SANTA MONICA

170.3

blue fin
CAFE & BILLIARDS

170.4

170.1
design firm VWA Group
designer Rhonda Warren
client Isla Mena
logo for Pool grill at luxury resort.

170.2
design firm Blanco Design
designer Shelly Blanco
client Cowboy Sushi Restaurant

170.3
design firm Vigon/Ellis
designer Marc Yeh
art director Larry Vigon
client SeaCastle
logo for Corporate identity.

170.4
design firm The Wecker Group
designer Robert Wecker
client Blue Fin Billiards
logo for All applications.

171.1
design firm De Muth Design
designer Roger De Muth
art director Betsy Borba
illustrator Roger De Muth
client Articulations/RCC Foods
logo for Seamore Fish identity image.

171.2
design firm Dean Mitchell Design
designer Dean Mitchell
illustrator Jon W. Wright
client Daiwa Fishing Tackle
logo for 1999 Catalog.

171.3
design firm The Wecker Group
designer Robert Wecker
client Blue Fin Billiards
logo for Signage, T-shirts.

171.1

171.2

171.3

172.1
design firm Akagi Remington
designer Dorothy Remington
client Tides Foundation
logo for New identity for the Tides Foundation and
 Tides Center, partners with donors to
 increase and organize resources for social
 change.

172.2
design firm Wolfback Design
designer Karin Scholz
client VM Labs
logo for Corporate ID for company in 3D-rendering
 technology for video games.

172.3
design firm Kevin Akers Designs
designer Kevin Akers
client Armanino McKenna
logo for CPA firm.

173.1
design firm The Wecker Group
designer Robert Wecker
client Monterey Pacific, Inc.
logo for Signage, stationery, forms.

173.2
design firm Alexander Atkins Design, Inc.
designer Alexander Atkins
client Alexander Atkins Design, Inc.
logo for Graphic design studio.

173.3
design firm Eve Vrla Design
designer Eve Vrla
client Mitsui Components (USA), Inc.
logo for Corporate identity, signage and packaging
 for automotive recycling plant.

173.4
design firm MJR Associates
designer Frank Ruiz
client Ponderosa Telephone
logo for Corporate identity used on stationery,
 signage and marketing materials.

TIDES
F O U N D A T I O N

172.1

VM LABS

172.2

ARMANINO McKENNA LLP
Certified Public Accountants & Consultants

172.3

MONTEREY PACIFIC
APPLIED
AGRICULTURAL
TECHNOLOGIES

173.1

173.2

MITSUI
Components (U.S.A.), Inc.

173.3

PonderosaTelephone

173.4

174.1

174.2

D A R I N I V E R S O N , D D S , L T D

174.3

174.4

sun 'n' sand

175.1

Lombard
BROKERAGE INC.

SM

175.2

kitcole
investment advisory services

TM

175.3

174.1
design firm Michael Osborne Design
designer Andy Cambouris
art director Michael Osborne
client Bidcom
logo for E-commerce.

174.2
design firm Shields Design
designer Charles Shields
art director Stephanie Wong
client Central Valley Business Incubator
logo for Entrepreneurial facilities.

174.3
design firm Innovative Design and Advertising
designers Mimi, Susan Nickey-Newton
art director Kim Crossett-Neumann
client Darin Iverson, DDS, LTD
logo for All corporate identity needs for
orthodontist.

174.4
design firm Michael Osborne Design
designer Michael Osborne
client San Francisco Museum of Modern Art
logo for Museum store.

175.1
design firm Juddesign
designer Vicki Wyatt
art director Patti Judd
client Sun 'n' Sand
logo for Volleyball sportswear/team uniforms.

175..2
design firm Kevin Akers Designs
designer Kevin Akers
client Lombard Brokerage
logo for Online brokerage company.

175.3
design firm Mortensen Design
designer Wendy Chon
art director Gordon Mortensen
client Kit Cole Investment Advisory Services
logo for Financial investment services.

centricity

176.1

176.2

176.3

176.4

176.1
design firm Fuse
designer Russell Pierce
client Centricity
logo for Overall corporate identity/brand, used in
 both print and digital mediums.

176.2
design firm Engle + Murphy
designer Emily Moe
client Centricomp
logo for Corporate ID for workers' compensation
 insurance company.

176.3
design firm Dutch Design
designer Rick Smits
client JW Builders
logo for Business cards.

176.4
design firm Shimokochi/Reeves
designer Mamoru Shimokochi
client Zig Ziglar Network Trademark
logo for Zinera: branding identity & packaging
 system/nutritional supplements.

177.1
design firm Eve Vrla Design
designer Eve Vrla
client Victoria Crawford
logo for Stationery and brochures for personal
 counseling business.

177.2
design firm Talbot Design Group
designer Chris Kosman
art director GayLyn Talbot
client Biometric Identification
logo for Identity and collateral.

177.3
design firm Shields Design
designer Charles Shields
art director Stephanie Wong
client Heberger & Company, Inc.
logo for Accounting firm.

177.4
design firm Stephgrafx
designer Stephanie Payan
client M Marketing Inc./Biokeys
logo for Pharmaceutical company.

177.5
design firm J. Robert Faulkner Advertising
designer J. Robert Faulkner
client Spellbound

the way of discovery

177.1

177.2

HEBERGER
&COMPANY
Certified Public Accountants

177.3

BIOKEYS
PHARMACEUTICALS

177.4

Strategic Event Design Spellbound Public Relations Marketing

177.5

tickmarksolutions

178.1

178.2

178.3

178.4

178.5

178.1
design firm Stone Yamashita
designer Jennifer Olsen
client Tickmark Solutions
logo for Business cards, letterheads, all print and
 web media for accounting services company.

178.2
design firm Tsuchiya Sloneker Communications, Inc.
designer Andrew Harding
art director Julie Tsuchiya
illustrators Andrew Harding, Julie Tsuchiya
client Ecast, Inc.
logo for Product identity—ads, website, collateral.

178.3
design firm Tsuchiya Sloneker Communications, Inc.
designer Doug Ridgway
art director Mark Sloneker
illustrator Doug Ridgway
client Evocative, Inc.
logo for Corporate identity, stationery system,
 collateral, website.

178.4
design firm Vigon/Ellis
designer Marc Yeh
art director Larry Vigon
client Pronounced Technologies Inc.
logo for Corporate identity.

178.5
design firm Conover
designer Carlos Avina
art director David Conover
client Sejerson DPS
logo for Digital film processor.

179.1
design firm Design Firm Alexander Atkins Design, Inc.
designer Alexander Atkins
client Stanford University
logo for Organization providing activities, services
 and benefits to alumni.

179.2
design firm Vigon/Ellis
designer Brian Jackson
art director Larry Vigon
client DIVA Systems Inc.
logo for Corporate identity.

179.3
design firm Taber Integrative Design
designer Michele Taber
client California Fair Services Authority
logo for Proposed logo for an organization providing
 members with specialized support services.

STANFORD
BUSINESS
SCHOOL
ALUMNI
ASSOCIATION

179.1

DIVA™

179.2

179.3

180.1
design firm B3 Design
designer Barbara B. Breashears
client Dolce Mia
logo for Handmade frames & collectibles.

180.2
design firm Bruce Yelaska Design
designer Bruce Yelaska
client Hunan Garden
logo for Chinese restaurant.

180.3
design firm The Wecker Group
designer Robert Wecker
client Ryan Ranch Rotisserie
logo for Signage, menus, stationery.

181.1
design firm McElveney & Palozzi Design Group, Inc.
art directors Steve Palozzi, Lisa Parenti
client Genessee Brewing Company
logo for Packaging and P.O.P. materials, sell
 sheets—Genny Summer Brew.

181.2
design firm McElveney & Palozzi Design Group, Inc.
art directors Steve Palozzi, Matt Garrity
client Genessee Brewing Company
logo for Packaging and P.O.P. materials, sell
 sheets—Genny Winter Brew.

181.3
design firm Pierre Rademaker Design
designers Pierre Rademaker, Marci Russo
client Mrs. Weinstein's Toffee
logo for Print items, product packaging, advertising.

181.4
design firm Dutch Design
designer Rick Smits
client Terpstra Custom Kitchens
logo for Stationery, business cards and vehicle graphics.

181.5
design firm Lawless Graphic Design
designer John P. Lawless
client Albany-Colonie Regional Chamber of
 Commerce
logo for Promotion and celebration of the 100th
 anniversary in the year 2000 of the
 Albany-Colonie chapter of the Chamber of
 Commerce.

181.6
design firm Mike Salisbury Communications
designer Mike Salisbury
client Jurassic Park

180.1

180.2

180.3

181.1

181.2

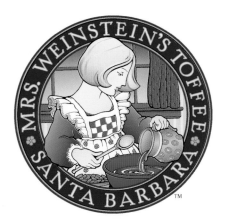

181.3

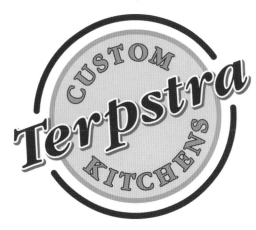

181.4

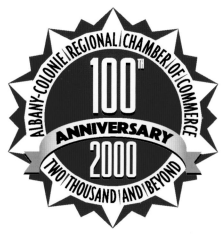

181.5

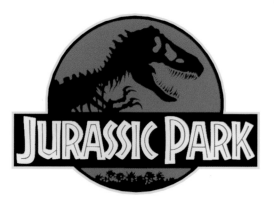

181.6

Western Bagel
SINCE 1947 ®

182.1

182.2

PASSPORT
TO SUCCESS

182.3

SNEAKY PETE'S

182.4

EXCLUSIVE MANUFACTURER FOR MASTERPIECE COOKIES
Internationally
DELICIOUS, INC.

182.5

GREAT
EXPECTATIONS
LIGHTING Co.

182.6

182.1
design firm GDS Studio
designer Gary Solomon
client Western Bagel
logo for Signage, uniforms, cups, mugs, trucks.
182.2
design firm Blanco Design
designer Shelly Blanco
client McHale Design

182.3
design firm Earlywine Design
designer Terry Earlywine
client SCO (Santa Cruz Operation)
logo for Product resellers program, packaging and
 collateral.

182.4
00.0
design firm Lawless Graphic Design
designer John P. Lawless
client Sneaky Pete's
logo for Popular area nightclub in Albany, New York.

182.5
design firm B3 Design
designer Barbara B. Breashears
client Internationally Delicious, Inc.
logo for Stationery, etc. for cookie manufacturer of
 Masterpiece Cookies.

182.6
design firm The Wecker Group
designer Robert Wecker
client Great Expectations Lighting Co.
logo for Stationery.

183.1
design firm J. Robert Faulkner Advertising
designer J. Robert Faulkner
illustrator Alex Marshall
client Scriveners' Society

183.2
design firm Boardwalk
designer Harriet Breitborde
client Staples Center
logo for Marketing/promotion and signage.

183.3
design firm Sabingrafik, Inc.
designer Tracy Sabin
art director Van Oliver
illustrator Tracy Sabin
client Uptown CarWash
logo for A carwash company.

183.1

183.2

183.3

design firm The Stricklin Companies
designers Ann Stricklin, Tom Allen
art director Steve Emtman
client American Family Film Foundation
logo for Charity identity for promotion, web site,
 marketing packages.

184.2
design firm Lorenz
designer Arne Ratermanis
client Monarch Brewery, LLC
logo for Restaurant identity.

184.3
design firm The Wecker Group
designers Robert Wecker, Matt Gnibus
client The DoubleTree Hotel/Monterey
logo for Pub signage, menus, specialty advertising.

185.1
design firm Mires Design
art director José Serrano
illustrator Tracy Sabin
client Troop 260, Boy Scouts of America
logo for T-shirt.

185.2
design firm Shields Design
designer Charles Shields
illustrator Doug Hansen
client Trinidad Cigar Emporio
logo for Cigar company.

185.3
design firm Maddochs & Co.
art director Clare Sebenius
illustrator Tracy Sabin
client El Cholo
logo for Mexican cantina.

185.4
design firm The Wecker Group
designer Robert Wecker
client The Hearth Shop
logo for Signage, stationery.

185.5
design firm David Carter Graphic Design
client Paris Resort and Casino
logo for La Rotisserie Des Artistes/Las Vegas,
 Nevada.

184.1

184.2

184.3

185.1

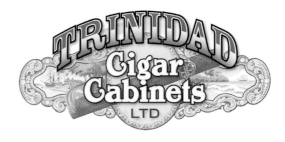

185.2

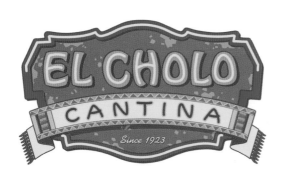

185.3

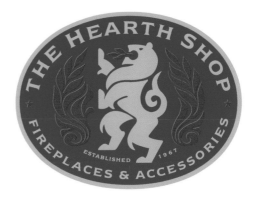

185.4

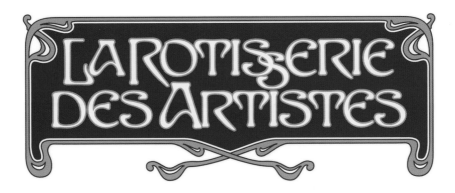

185.5

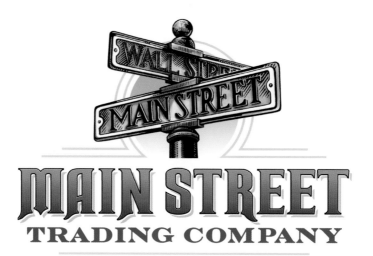

MAIN STREET
TRADING COMPANY

186.1

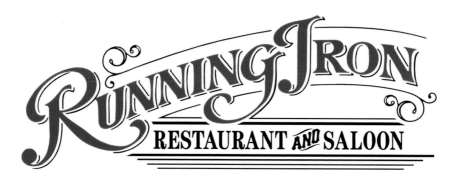

186.2

186.3

186

186.1
design firm	Shields Design
designer	Charles Shields
illustrator	David Wariner
client	Main Street Trading Company
logo for	Investment company.

186.2
design firm	The Wecker Group
designer	Robert Wecker
illustrator	Mark Savee
client	Running Iron Restaurant
logo for	Signage, T-shirts.

186.3
design firm	McElveney & Palozzi Design Group, Inc.
art directors	William McElveney, Jon Westfall
client	Watt Farms Country Market
logo for	Letterhead, business cards, envelopes.

187.1
design firm	Primo Angeli Inc.
designers	Kelson Mau, Philippe Becker
art director	Rich Scheve
client	Ben & Jerry's
logo for	Ben & Jerry's ice cream cartons.

187.2
design firm	Primo Angeli Inc.
designers	Koji Miyaki, Harumi Kubo
art director	Steve Lindsay
client	Pharmavite
logo for	Nature Made.

187.3
design firm	Primo Angeli Inc.
designers	Jasmine Gerber, Toby Sudduth
art director	Steve Lindsay
client	PowerBar Inc.
logo for	Perform.

187.1

187.2

187.3

188.1
design firm The Wecker Group
designer Robert Wecker
illustrator Mark Savee
client Red's Donuts
logo for Signage, packaging, forms.

188.1

188.2
design firm Leeson Design
designer Susan Leeson
client Franklin's Family Auto Care
logo for Family-owned auto repair shop.

188.3
design firm The Wecker Group
designer Robert Wecker
client Caruso's Corner
logo for All applications.

189.1
design firm Jeffry Hipp
designer Jeffry Hipp
client Model T Ford Club of American
logo for Inland Empire Chapter/Flivvers 'n Rivers,
 the MTFCA's Western National tour.
 Logo and embroidered patch.

189.2
design firm Shields Design
designer Charles Shields
client The Ken Roberts Company
logo for Investment program.

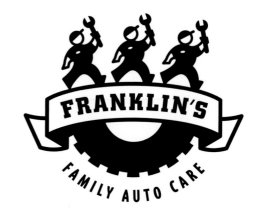

188.2

189.3
design firm Lawless Graphic Design
designer John P. Lawless
client Seacrets
logo for Popular under 21 night club.

189.4
design firm McElveney & Palozzi Design Group, Inc.
art directors William McElveney, Ellen Johnson
client Fieldbrook Farms, Inc.
logo for Sell sheets.

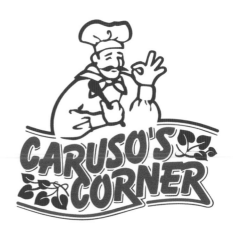

188.3

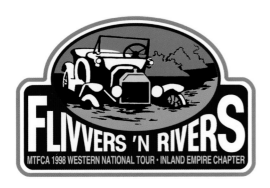

189.1

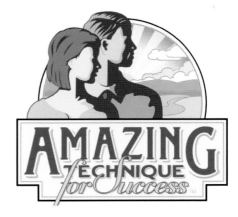

89.2

189.3

189.4

190.1

190.2

190.1
design firm	Wolfback Design
designer	Karin Scholz
client	Institute for Women & Technology
logo for	Corporate ID for organization promoting growth and revolutionary ideas in technology.

190.2
design firm	Bruce Yelaska Design
designer	Bruce Yelaska
client	Bikram's Yoga College of India
logo for	Yoga school.

190.3
design firm	Tsuchiya Sloneker Communications, Inc.
designer	Andrew Harding
art director	Julie Tsuchiya
illustrator	Andrew Harding
client	Ecast, Inc.
logo for	Corporate identity—stationery system, collateral, website, ads.

191.1
design firm	Alexander Atkins, Inc.
designer	Alexander Atkins
client	Spiral Communications
logo for	Public relations firm.

191.2
design firm	Tom Fowler, Inc.
designer	Elizabeth P. Ball
client	IBC
logo for	Conveying the emerging interactive relationship between Unilever HPC's consumers, customers and suppliers.

190.3

SPIRAL
COMMUNICATIONS

191.1

Interactive Brand Center

191.2

192.1
design firm Morreal Graphic Design
designer Mary Lou Morreal
client Upper Deck
logo for Trading card.

192.2
design firm Kevin Akers Designs
designer Kevin Akers
client Jack Lemmon Invitational Golf Tournament
logo for Celebrity golf tournament in Pebble Beach,
California.

192.3
design firm Disney Consumer Products
designer Logo Doctor
art director Kirsti Ronback
illustrator Teri Klass
client Los Angeles Angels
logo for Merchandising.

193.1
design firm The Wecker Group
designer Robert Wecker
client Carmel Valley Inn & Tennis Resort

193.2
design firm The Wecker Group
designer Robert Wecker
client Pacific Grove Rotary Club
logo for Event signage.

193.3
design firm Shields Design
designer Charles Shields
client The Zone Sportsplex
logo for Sports facility.

193.4
design firm Allen Orr
designer Allen Orr
client Olympic Soccer 2000 Australia
logo for Student project.

193.5
design firm The Wecker Group
designer Robert Wecker
client City of Monterey
logo for Signage, stationery, forms.

192.1

192.2

192.3

193.1

193.2

193.3

193.4

MONTEREY
SPORTS CENTER

193.5

HONDA
GRAND PRIX OF MONTEREY
FEATURING THE Shell 300

194.1

ALLCAR
MOTORSPORTS
BOBBY ALLISON / DAVE CARROLL MOTORSPORTS

194.2

194.3

194.4

194.5

195.1

195.2

195.3

194.1
design firm The Wecker Group
designer Robert Wecker
client Laguna Seca Raceway
logo for Signage, programs, TV advertising.

194.2
design firm The Wecker Group
designer Robert Wecker
client Allcar Motor Sports
logo for All applications.

194.3
design firm The Wecker Group
designer Robert Wecker
client Laguna Seca Raceway
logo for Signage, programs, TV advertising.

194.4
design firm Primo Angeli Inc.
designer Philippe Becker
art director Carlo Pagoda
client Championship Auto Racing Team Inc.
logo for Championship auto racing team.

194.5
design firm Mike Salisbury Communications
designer Logo Doctor
art director Mike Salisbury
illustrator Tim Clark
client Malibu Grand Prix
logo for Promotional event.

195.1
design firm Studio Seireeni
designer Logo Doctor
art director Rick Seireeni
illustrator Tim Clark
client NY Knicks
logo for Proposed identity for merchandising.

195.2
design firm Pierre Rademaker Design
designers Pierre Rademaker, Jeff Austin
client USA Sports Mecca
logo for Print items, apparel, collateral.

195.3
design firm Mires Design
art directors John Ball, Myles McGuinness
illustrator Tracy Sabin
client Harcourt Brace & Co.
logo for Children's literature book.

NANCY**LOPEZ**GOLF™

196.1

PALMER | GOLF

BUILT TO HIT IT

196.2

196.3

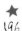

196

196.1
design firm Miriello Grafico, Inc.
designer Courtney Mayer
art director Ron Miriello
client Nancy Lopez Golf
logo for Various marketing materials, exhibit
 materials and product identity.

196.2
design firm Miriello Grafico, Inc.
designers Courtney Mayer, Chris Keeney
art director Ron Miriello
client Arnold Palmer Golf

196.3
design firm Kevin Akers Designs
designer Kevin Akers
client Mervyns California
logo for Icon for men's clothing line.

197.1
design firm GDS Studio
designer Gary Solomon
illustrator Chip Pace
client Mono Lake Committee
logo for Posters, racing jerseys, brochures to
 promote annual race on bicycles from
 LA to Mono Lake.

197.2
design firm Vitro/Robertson
art director John Bade
illustrator Tracy Sabin
client Shimano Resort
logo for Promotion of summer activities at a
 family resort.

197.3
design firm Bryan Friel Studio
designer Bryan Friel
client Washington State University Track & Field
logo for Sportswear, posters.

197.1

197.2

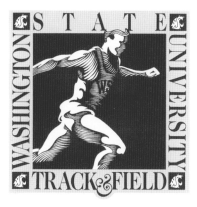

197.3

198.1
design firm Seaman Design Group
designer Robin Seaman
art director Dan Simon
illustrator Robin Seaman
client Los Angeles Dodgers
logo for A new line of retail children's apparel called
Dodgers Baby Blue.

198.1

198.2
design firm Kevin Akers Designs
designer Kevin Akers
client Cross Training
logo for Focus on the family magazine article on
keeping teens fit.

198.3
design firm Seaman Design Group
designer Robin Seaman
art director Dan Simon
illustrator Robin Seaman
client Los Angeles Dodgers
logo for A new line of retail children's apparel called
Dodgers Baby Blue.

199.1
design firm Miriello Grafico, Inc.
designer Dennis Garcia, Maximo Escobedo
client San Diego Crew Classic

199.2
design firm Jon Briggs Design
designer Jon Briggs
client The Upper Deck Company
logo for Proposed logo for apparel line (T-shirts).

199.3
design firm Kevin Akers Designs
designer Kevin Akers
client Motorcycle Industry Council
logo for Promotion of motorcycle sports.

198.2

198.3

199.1

199.2

199.3

200.1

design firm John Champ Design Associates
designer Randall Cohen
art director Denise St. Louis
illustrator Randall Cohen
client KCBS/KLLC Radio Alice@97.3
logo for Event identity for festival and concert.

200.2

design firm Primo Angeli Inc.
designer Terrence Tong
art director Rich Scheve
illustrator Mark Jones
client Silicon Gaming
logo for Odyssey.

200.3

design firm Tsuchiya Sloneker Communications, Inc.
designer Dolin O'Neill
art directors Julie Tsuchiya, Mark Sloneker
illustrator Colin O'Neill
client Eastman Kodak/Themed Entertainment
logo for Service logo—collateral, film, trailers, ads.

200.4

design firm Kevin Akers Designs
designer Kevin Akers
client Gren Fed
logo for Offshore bank located in Grenada.

201.1

design firm Zamboo
designers Dave Zambotti, Chris Go
art director Becca Bootes
client SolSource Innovations
logo for Corporate identity.

201.2

design firm Stewart Monderer Design, Inc.
designer Aime Lecusay
art director Stewart Monderer
client League School of Greater Boston
logo for Identity.

201.3

design firm Fuse
designer Russell Pierce
client PairGain (Star Gazer)
logo for Software, used in digital mediums and
 packaging.

201.4

design firm Engle + Murphy
designer Emily Moe
client Pacific Western National Bank
logo for Corporate ID. The bank decided to
 update their logo and look for their 20th
 anniversary and new headquarters.

200.1

200.2

200.3

200.4

201.1

201.2

201.3

201.4

DANIEL LANE

Enrolled Agent
Financial and
Tax Planning

"Your Road To Financial Success"

202.1

CENTRAL CALIFORNIA
MERCY FLIGHT

202.2

DAVID LOOP EUROPEAN PARTS & SERVICE

202.3

202.1
design firm The Wecker Group
designer Robert Wecker
client Daniel Lane
logo for Signage, stationery.

202.2
design firm The Wecker Group
designer Robert Wecker
client Mercy Flight/Central California
logo for Signage, stationery.

202.3
design firm The Wecker Group
designer Matt Gnibus
art director Robert Weckerc
client David Loop European
logo for Signage, stationery.

203.1
design firm Earlywine Design
designer Terry Earlywine
client Teknekron
logo for Client seminar "Strategic Direction."

203.2
design firm B3 Design
designer Barbara B. Breashears
client TR@KS
logo for Stationery system, computer kiosks,
 web design, etc. for Transportation
 Resources @ Kiosk Sites.

203.3
design firm Pierre Rademaker Design
designers Pierre Rademaker, Jeff Austin
client Sphere Gift Shop
logo for Print items, packaging, signage.

203.1

203.2

203.3

204.1

204.2

204.3

205.1

205.2

205.3

204.1
design firm Alexander Atkins Design, Inc.
designer Alexander Atkins
client College
logo for Orientation week at college.

204.2
design firm Seaman Design Group/Willardson & Assoc.
designer Robin Seaman
art director Dan Simon
illustrator Robin Seaman
client Limited Too
logo for Apparel signature identification designed for
 embroidery onto new line of camp shirts,
 graphics to have the same look and feel as
 for their adult apparel.

204.3
design firm Bryan Friel Studio
designer Bryan Friel
client Blue Yonder Tours
logo for Stationery, ads, promotional items.

205.1
design firm Kevin Akers Designs
designer Kevin Akers
client Passport Wine Club
logo for Wine-of-the-month-club.

205.2
design firm Discovery Design Group
designer Logo Doctor
art director Dan Cavey
illustrators Tim Clark, Teri Klass
client The Discovery Channel
logo for Press kit and on-air broadcast.

205.3
design firm Moonlight Design
designer Karen Ryan
art director David Ryer
client Barnstorm Entertainment
logo for Cross-media production company, including
 music, film and video.

World Caravan

206.1

206.2

ODYSSEY

206.3

206.1
design firm Curtis & Company
designer Logo Doctor
art director Joe Curtis
illustrator Teri Klass
client World Caravan Concepts
logo for Proposed identity.

206.2
design firm Kevin Akers Designs
designer Kevin Akers
client Santa Maria Shipping
logo for Shipping company,

206.3
design firm Sabingrafik, Inc.
art director Lisa Peters
illustrator Tracy Sabin
client Harcourt Brace & Co.
logo for Publisher's imprint.

207.1
design firm Pierre Rademaker Design
designers Pierre Rademaker, Jeff Austin
client Rusack Vineyards
logo for Wine labels, tasting room signage,
 point of purchase signage.

207.1

208.1
design firm Stoyan Design
designer Michael Stinson
art director David Wooters
illustrator Michael Stinson
client Virtrue

208.2
design firm McElveney & Palozzi Design Group, Inc.
art directors Steve Palozzi, Matt Nowicki
client Factura
logo for Sell sheets.

208.3
design firm Michael Osborne Design
designer Michelle Regenbogen
art director Michael Osborne
client Asera
logo for E-commerce.

208.4
design firm Michael Osborne Design
designer Nicole Lembi
art director Michael Osborne
client Vitessa
logo for E-commerce.

209.1
design firm Stewart Monderer Design, Inc.
designer Aime Lecusay
art director Stewart Monderer
client Expand Networks, Inc.
logo for Identity.

209.2
design firm Solution 111 Design
designer Darryl Glass
client Solution 111 Design
logo for Stationery for Solution 111 Design,
 a graphic design studio.

209.3
design firm Eve Vrla Design
designer Eve Vrla
client Ensemble
logo for Corporate identity for real estate firm.

209.4
design firm Juddesign
designer Eric Watanabe
art director Patti Judd
client Furniture Resources
logo for Commercial office furniture.

Virtrue

208.1

Alliance
BY FACTURA
™

208.2

AserA

208.3

Vitessa

208.4

E X P A N D

networks

209.1

DESIGN

209.2

EN**S**EMBLE™

I N V E S T M E N T S, LLC

209.3

BUSINESS FURNITURE SOLUTIONS

209.4

210.1

210.2

210.3

210.4

210.5

210.6

211.1

211.2

211.3

10.1
design firm Moonlight Design
designer Karen Ryan
art director David Ryer
client Keigre Studios
logo for A photographer.

210.2
design firm Sandy Gin Design
designer Sandy Gin
client bingwear
logo for A clothing company.

210.3
design firm Q Studio
designer Lan Khiew
client Okiwa Pro-Sound Version
logo for New corporate identity & products.

210.4
design firm Allen Orr
designer Allen Orr
client The Tara Theater
logo for The 40th anniversary of the movie Psycho.

210.5
design firm Deluxe Brand
designer Tor Naerheim
client Pimp Wear
logo for Line of clothing.

210.6
design firm Deluxe Brand
designer Tor Naerheim
client Deluxe Brand
logo for In-house Deluxe Brand identity.

211.1
design firm Fitch
designer Cris Logan
art director Vassoula Vasiliou
client Kärna LLC
logo for Product packaging, marketing materials,
 websites. Product icon for new gamer
 mouse-razer boomslang.

211.2
design firm Lorenz
designer Arne Ratermanis
client San Diego Christian Unified School District
logo for Fund raising event.

211.3
design firm Mortensen Design
designer Wendy Chon
art director Gordon Mortensen
client CallTheShots
logo for Internet company.

MARQUE DÉPOSÉE

212.1

212.2

212.3

212

212.1
design firm Deluxe Brand
designer Tor Naerheim
client Deluxe Brand
logo for In-house Deluxe Brand identity.

212.2
design firm Elixir Design
designer Jennifer Jerde
illustrator Skylar Nielsen
client Christian Dauer
logo for Architect specializing in custom interiors
 and furniture.

212.3
design firm Mike Salisbury Communications
designer Mike Salisbury
illustrator Brian Sisson
client Disney
logo for Ed Wood

213.1
design firm Evolution Design
art directors Bear Files, Annie Files
client Garden Fresh Restaurant Corporation
logo for Ladles Soup & Salad Takery—
 a new restaurant chain.

213.1

213.2

213.2
design firm MJR Associates
designer Frank Ruiz
client Bayshore International
logo for Corporate identity used on stationery,
 signage, vehicles, and marketing materials.

213.3
design firm LF Banks + Associates
designer Cesar Varela
art director Lori F. Banks
client LF Banks + Associates
logo for Corporate identity for graphic design firm.

213.3

213.4
design firm Primo Angeli Inc.
designers Harumi Kubo, Toby Sudduth
art director Steve Lindsay
client PowerBar Inc.
logo for Essentials.

213.4

★
213

ONE RAFFLES LINK

214.1

GUTTMAN & BLAEVOET
Mechanical Engineers

214.2

214.3

KOKO KANU

214.4

JONELLE WEAVER

214.5

215.1

ATHLETA

215.2

Z.CAVARICCI

215.3

214.1
design firm	Calori & Vanden-Eynden
designer	Chris Calori, Judy Gee
art director	David Vanden-Eyden
client	HongKong Land Limited
logo for	Office building which encompasses both modern and classic architectural styles.

214.2
design firm	Benita Oberg Design
designer	Benita Oberg
client	Guttman & Blaevoet
logo for	Stationery, business cards, letterhead, envelopes, collateral, signage for mechanical engineers.

214.3
design firm	Lawless Graphic Design
designer	John P. Lawless
client	Planet Magic Productions
logo for	Magic Live, a series of magic shows at Historic Schenectady Theater (Proctors) featuring top national acts such as the Pendragons.

214.4
design firm	Susan Meshberg Graphic Design
designer	Susan Meshberg
client	Carriage House Imports Ltd.
logo for	Packaging (label) and promotion for a high-proof Rum.

214.5
design firm	Elixir Design
designer	Jennifer Tolo
art director	Jennifer Jerde
client	Jonelle Weaver Photography
logo for	The photographer's still life work and her personal taste for old, out-of-the ordinary objects.

215.1
design firm	Lawless Graphic Design
designer	John P. Lawless
client	First Steps Mediation Centers
logo for	Mediation consultant firm for divorcing couples.

215.2
design firm	Elixir Design
designer	Nathan Durrant
art director	Jennifer Jerde
client	Athleta
logo for	Women's sporting goods catalog.

215.3
design firm	Inhouse Design Department
designer	Lesli Wuco-B
client	Z. Cavaricci Clothing
logo for	Corporate/packaging & clothing labels/Website.

Fine Furnishings and Design

CLASSIC INTERIORS

216.1

THE

KEN ROBERTS

Gallery

216.2

216.1
design firm Conover
designer Amy Williams
art director David Conover
client Classic Interiors
logo for Interior design firm.

216.2
design firm Shields Design
designer Charles Shields
client The Ken Roberts Company
logo for Gallery.

217.1
design firm The Wecker Group
designer Robert Wecker
client The DoubleTree Hotel/Monterey
logo for Restaurant signage, menus.

217.2
design firm Stark Designs
designer Amy Stark
client Lena Fallica
logo for A house cleaning business.

217.3
design firm Pierre Rademaker Design
designer Pierre Rademaker, Jeff Austin
client Santa Barbara Farms
logo for Print items, advertising, shipping cartons,
vehicles, product tags.

217.4
design firm Susan Meshberg Graphic Design
designer Susan Meshberg
illustrator Jia Hwang, Marie Hiraga
client Wedgie Dietetic Foods
logo for Product packaging for organic food line.

217.1

217.2

217.3

217.4

★

phot.ogra.phy

218.1

Inventure ?lace

218.2

218.3

218.4

218.1
design firm Allen Orr
designer Allen Orr
client Tim Adkins Photography

218.2
design firm Calori & Vanden-Eynden
designer Gina De Benedittis
art director David Vanden-Eynden
client Inventure Place
logo for National Inventors Hall of Fame.
Museum and hall of fame complex
dedicated to discovery and invention.

218.3
design firm ComCorp, Inc.
designer Dave Lawrence
art director Debbie Werner
client Jones Lang LaSalle
logo for Property marketing material.

218.4
design firm Stoyan Design
designer Michael Stinson
illustrator Michael Stinson
client Stellar Road

219.1
design firm Bryan Friel Studio
designer Bryan Friel
client On The Mark Communications
logo for Marketing.

219.2
design firm Pat Davis Design
designer Susan Leeson
client Belle Cooledge Library
logo for Public library.

On the Mark
COMMUNICATIONS

219.1

Belle
Cooledge
LIBRARY

219.2

220.1

220.2

220.3

220.4

220.5

HAUTe
DECOR
.COM

221.1

MITCHELL MANAGEMENT ASSOCS.

221.2

221.3

220.1
design firm	Moonlight Design
designer	David Ryer
client	Rebel Planet Studios
logo for	British film production company.

220.2
design firm	The Marketing Store
designer	Susan Leeson
client	The Marketing Store
logo for	Marketing/communications firm.

220.3
design firm	Tharp Did It
designers	Rick Tharp, Nicole Coleman
client	divio
logo for	Identifying video compression technology.

220.4
design firm	Lawless Graphic Design
designer	John P. Lawless
client	Blue Mule Bar & Grill
logo for	Business logo for bar and grill.

220.5
design firm	Calori & Vanden-Eynden
designer	Chris Calori, Denise Funaro
client	Dark Horse Theater Company
logo for	Small, regional theater company.

221.1
design firm	Tom Fowler, Inc.
designers	Thomas G. Fowler, Elizabeth P. Ball
client	Haute Decor.com
logo for	Company that facilitates on-line sales of high quality home and office furnishings through virtual showrooms created by acclaimed interior designers.

221.2
design firm	Lawless Graphic Design
designer	John P. Lawless
client	Mitchell Management Associates
logo for	Marketing research firm.

221.3
design firm	Calori & Vanden-Eynden
designers	Chris Calori, David Vanden-Eyden
client	PIG X Annual Pig Roast
logo for	10th annual pig roast and social event.

222.1
design firm The Wecker Group
designer Robert Wecker
client Soquel Creek Water District
logo for Signage, stationery, forms.

222.2
design firm The Wecker Group
designer Robert Wecker
client Carmel Area Waste Management District
logo for All applications.

222.3
design firm Vigon/Ellis
designer Brian Jackson
art director Larry Vigon
client Pacific Coast Hotels
logo for Corporate identity.

223.1
design firm The Wecker Group
designer Robert Wecker
client Carmel Marina Corporation
logo for All applications.

223.2
design firm The Wecker Group
designer Robert Wecker
client Monterey Peninsula Water Management
logo for Signage, stationery, collateral.

223.3
design firm Innovative Design and Advertising
designers Brandon Bennett, Susan Nickey-Newton
art director Kim Crossett-Neumann
client VICO
logo for Labels and ads for pump (whirlpool)
 manufacturer to identify strength of their
 product.

223.4
design firm The Wecker Group
designer Robert Wecker
client CSU Monterey Bay
logo for Stationery.

223.5
design firm Kevin Akers Designs
designer Kevin Akers
client Bay One Technologies
logo for San Francisco-based software developer.

SOQUEL CREEK WATER DISTRICT

222.1

CARMEL AREA WASTEWATER DISTRICT · SINCE 1908 ·

222.2

222.3

CARMEL MARINA CORPORATION

223.1

223.2

whirlpool operating wonder

223.3

FRIENDS OF CALIFORNIA STATE UNIVERSITY MONTEREY BAY

223.4

bay one technologies

223.5

★
223

eventra

224.1

annuncio

224.2

PONDFISH

224.3

GULLIVER
B O O K S

224.4

224.1
design firm Tom Fowler, Inc.
designer Karl S. Maruyama
client Eventra
logo for Differentiating Eventra from other commerce/electronic data interface companies and positioning it as a 21st century global EC/EOI player.

224.2
design firm Focus Design
designer Brian Jacobson
client Annuncio Software
logo for Corporate identity.

224.3
design firm Allen Orr
designer Allen Orr
client Pondfish Fishstore

224.4
design firm Sabingrafik, Inc.
art director Lisa Peters
illustrator Tracy Sabin
client Harcourt Brace & Co.
logo for Publisher's imprint.